WITNESS

CHAIR

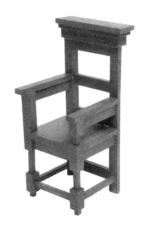

WITNESS CHAIR

A Memoir of Art,
Marriage, and Loss

SHERRY HORTON

Shanti Arts Publishing
Brunswick, Maine

WITNESS CHAIR

A Memoir of Art, Marriage, and Loss

Published by Shanti Arts Publishing
Cover and interior design by Shanti Arts Designs

Shanti Arts LLC
193 Hillside Road,
Brunswick, Maine 04011
shantiarts.com

Printed in the United States of America

First edition
10 9 8 7 6 5 4 3 2 1

ISBN: 978-1-941830-36-9 (softcover)
ISBN: 978-1-941830-37-6 (digital)

Library of Congress Control Number: 2016942223

for Chris

Contents

"The ultimate touchstone is witness, the privilege of having been seen by someone and the equal privilege of being granted the sight of the essence of another, to have walked with them and to have believed in them, and sometimes just to have accompanied them for however brief a span, on a journey impossible to accomplish alone."

— David Whyte, *Consolations: The Solace, Nourishment and Underlying Meaning of Everyday Words*

PROLOGUE

May 2004
University of Connecticut Health Center

UNFAZED BY TWO weeks of chemo, Chris sits up in the hospital bed — with a full head of white hair and a hint of peach in both cheeks — still looking like the tall, athletic artist I married. His back propped against two pillows, he manages the tangle of IV lines while writing with a drawing pencil in the oversized sketchbook cradled on another pillow in his lap and held firmly open with his left hand. Now and then he stops to pick up the blueprints next to him on the bed and studies the designs for a series of abstract sculptures. He is so intent on the art project begun years ago that he's forgotten I'm sitting here just a couple of feet away in the green La-Z-Boy, writing in my journal.

Chris and his artist-friend, Peter McLean, submitted their idea to a national competition to commemorate the 1692 Salem Witch Trials. Their idea consists of sixteen small, basswood maquettes that, if built, will be huge, eighteen-foot, steel, chair-like outdoor sculptures. A brief text accompanying each chair explores possible reasons for and effects of that strange history. Chris works on the project every day he's strong enough, determined to think, to create.

Interested in the history, I discuss and edit the drafts with him, aware that my ancestors on both sides emigrated from England in the 1620s and '30s to settle within the Massachusetts Bay Colony in areas north and west of Boston. By 1692 they had survived for two or three generations and had carved out villages from a forbidding wilderness, had farmed and traded, and developed a government and church organizations. Some perished in the First and Second Indian Wars that threatened the existence of the New World.

One survivor of those wars was my eighth great grandmother, Hannah Dustin. In 1697, five years after the witch trials began, she gave birth at forty to her eleventh child at her home in Haverhill, Massachusetts. Less than a week later Wabanaki Indians abducted her, along with many others, in a coordinated raid on the town. They smashed her newborn against a tree. Held captive for two weeks, heading west for more than a hundred miles on foot, she, with two cohorts, finally escaped one night by stealing hatchets and scalping ten Indians, six of whom were children. Scalps in hand, they paddled a stolen canoe down the Merrimack River back to Haverhill.

While such murderous confrontations were not unusual in that violent frontier existence, Hannah Dustin's desperate act—being a mother capable of scalping children—was unheard of in that, or any, time. Over the centuries her infamy has inspired both pride and condemnation. In the nineteenth century, none other than Nathaniel Hawthorne called her a "hag," affronted by the image of womanhood she represented. Her legacy continues to be debated, not only by scholars and historians, but by citizens of Haverhill, who, as recently as 2006, nearly came to blows over a proposed statue of her. Appalled by that history, some residents refuse to honor her.

Is there a smidgen of Eighth Great Gram in my genes? Can I do whatever it takes to survive, as she did? Who will I become in the process?

Putting down his pencil, Chris looks up at me, his wife of thirty-nine years. "Would you read this draft?"

"Sure." I reach for the sketchbook and settle back, prop it against my knees, my feet pressing against the elevated foot rest. Retired English teacher, I am on call for editing assistance. I already know that the decision to use the chair form for these sculptures derived from one of the Salem stories: the elderly Rebecca Nurse, first of many accused of being a witch and later hanged, was so infirm she had to be carried in a chair from her home to the courthouse. The three young girls who set off the crisis were found hysterical, crouching under chairs in the Reverend Samuel Parris's dining room, seemingly bewitched.

I read, "Chairs are universal structures of comfort, power, position, role, exchange, responsibility, hospitality, governance, and sociability. They are ongoing props in the narrative of life." Scanning the next few sentences, I pause and look up at Chris. "I love the phrase 'ongoing props in the narrative of life,' but the list of nouns in the first sentence is a little long. Maybe use three or four, not nine." I hand it back, confident he will take my editing suggestion, as he usually does.

But why is Chris still working on this piece? Why did he pick it up again? Although their proposal received only an honorable mention in the competition, and only one of the sculptures, Jacob's Ladder, has been built, he is determined to complete the project. He says chairs are iconic. Sitting in a chair, you seem to conform, willing to participate in what is about to occur—a performance, a lesson, an interrogation, a meal, a cancer treatment. There are rules regarding chairs. You are expected to sit calmly, respond appropriately, relinquish control. Having lost control of his body, Chris hears the dreaded news in chairs in doctors' offices, a humiliating experience. Now captive in a hospital, he fights back with his only weapon—art.

Each of the abstract, chair-like maquettes is empty, containing nothing that was in it and everything that was and could be in it. Each chair invites a viewer to imagine sitting down and sinking into the experience of being in that chair at any moment in time. The Accused Chair (which is on the cover of this book) represents how it feels to be struck where you sit. Out of the blue, a bolt

of aggression, of horror, pins you down, a victim of physical or psychological violence, as was Hannah Dustin. Assuming your innocence, you may be unconscious of your possible complicity in events leading to the stunning moment of assault.

Chris witnesses history and translates the Salem story into a tangible form for a contemporary world. I witness Chris. Each vigilant day, I sit spine stiff in an unforgiving hospital chair, armed against an onslaught of test results. Only when we are alone on a weekend like this, or when day shifts end in dim evening light, do I retreat to the recliner and record what doctors have said, what has happened that day. And when memories of our forty years together interrupt the inevitable tide, I witness those, too, our past as a couple contained in every present moment of our gradual uncoupling.

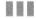

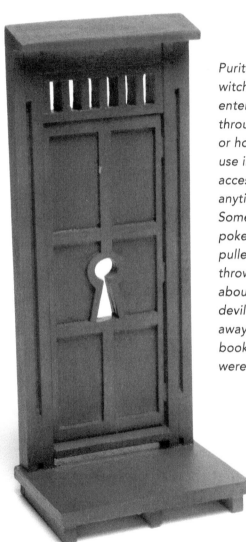

Puritans believed that witches were able to enter a house or room through the smallest crack or hole. Locks were of no use in preventing their access and appearance anytime and anywhere. + Some victims — pinched, poked, speared, pushed, pulled, stretched, bitten, thrown down, and tossed about — converted to the devil's side and signed away their lives in his evil book. Hundreds of others were constantly harassed.

Witch's Keyhole Chair

April 2004

I TRAIL CHRIS WITHIN A WAVE of tourists as we slide, seemingly en masse, from one gallery to another in the Barnes Foundation near Philadelphia, his 6'2" height and silver head easy to spot as he studies the crowd of paintings by post-impressionists, including Manet, Sisley, and Renoir. Passionate about art history, he made the appointment months ago to visit this collection, about a five-hour drive from home. If we arrived late we wouldn't get in, so we pushed it and got here just in time.

I have followed Chris through museums all over Europe, waiting for him in one gallery after another, drooped and dopey on a hard wooden bench as he concentrated on the artwork. He seemed to travel alone to another era, and I never knew what he was thinking. Today it's the late nineteenth century, when painters used pastels and short brushstrokes to alter our perception of everything we think we see: sky, field, mountain, the very air we breathe. I too love these paintings, particularly those of Cézanne.

On this morning, though, something I can feel but not see disturbs me, distracting me from the famous artwork. I see only Chris. It's as if I'm peering at him through the over-sized keyhole in the Witch's Keyhole Chair, which looks more like a door, the

opening between inside and outside an opportunity for something, anything—a witch, the devil, a Wabanaki Indian, an idea or belief—to enter, to enter and sit down, to enter and take up residence inside.

In the same way, something unknown—perhaps evil, perhaps not—has entered my husband's body, has snuck in and sat down in his body-chair and decided it's nice enough to stay. A while. Hopefully a short while. But what is it, and how did it enter? And why visit Chris, why Chris and me? Whatever is going on, I automatically think it's our fault. I should have been paying attention. The narrow space between things that hovers alongside consciousness like a crevice, chink, or interstice is making itself known, a rattling, crackling confrontation.

When Chris first began feeling weak about a month ago, it was of course because I had insisted we follow the South Beach Diet precisely for two weeks: every Smiling Cow cheese wedge, every low-fat mozzarella stick, every ricotta and Splenda dessert. No sugar, no alcohol. He quickly lost fifteen pounds, propelling him toward the range recommended for his rugged frame. But he concluded that losing weight made him weak, complaining he could swim only half the usual number of laps at the University pool.

That he became weak happened more than once. I wondered aloud, searching for something to blame. Maybe he'd caught a bug, maybe the flu. The fatigue continued. A week or two later, while showering he noticed a scaly, dime-sized eruption on one shoulder and another on his waist, and made an appointment with our primary care physician who sent him to a dermatologist who discovered half a dozen large, flat blotches, like purple puddles, all over his scalp, hiding under his silver hair.

When Chris and I met in 1964 while teaching at Suffield High School in Connecticut, he had thick, wavy, dark brown hair and a dark, full beard. He was an artist and art teacher, after all, who ignored the pointed suggestion of the superintendent of schools to neaten up. He shaved his beard only once, later in the '70s, when we appeared in drag at a Hartford Art School Halloween party. Our costumes won first prize—a fifth of gin—because no

one recognized the towering, curvaceous "woman" in a smooth, blond pageboy wig, mini skirt, black tights, and high heels, not even "her" closest colleague, Peter McLean. After the party I implored Chris to grow his beard again, and he did.

His hair has been thinning, yes, but not enough to reveal these blotches. A stealth attack. Suspicious spots, doctors agreed. "We'll know more in a week," they said after the biopsy. A heaviness we can't escape or ignore, like nausea, swallows our special weekend in Philadelphia, including a late dinner with dear friends and a spontaneous decision to see whatever was playing at the theater next door. We see *Les Invasions Barbares*, a Canadian film about assisted death, in which the dying professor's millionaire son provides a lakeside cottage, a celebratory spaghetti dinner with old friends, mistresses — it's very French — and heroin for the final event. One family's end-of-life story, funny and joyful as well as mournful, stuns me with its incredible portent. I can't speak of it, even when the four friends discuss our reactions to the film. Words would make it real. That weekend I suppress our secret about Chris's health from one of my oldest friends — call it my secret witchery.

CHRIS IS SITTING UP on the table in a tiny examining room at the cancer center. I'm in the only chair, hard wood, straight backed. Fluorescent lights glare. We look at each other with anguish laced with relief that we will have an answer. After examining the spots and probing most of his body, the doctor has left to check his blood numbers. I stare at the walls without seeing the large illustrations of the beautiful, intricate systems of the human body. We wait. When the doctor returns, he knows more. "The red cell count is half what it should be. We'll do a bone marrow test tomorrow morning."

What does it all mean? Why are his red cells down? I don't know anything about bone marrow, I realize, my mind flooded with questions. Chris speaks up quickly. "I assumed I would have lung cancer because my mother died of it and we were both lifelong smokers."

"No," the doctor says, disputing Chris's theory. "When the blood

cells are 'off' they wander through the body and collect somewhere in the skin, hence the spots on your skull and shoulder. So it's probably leukemia or a lymphoma." He drops these words like bombs.

Oh no, oh no, my mind shouts, and instantly conjures the image of Chris's friend who's had chronic leukemia for years and continues to work and travel. We drive home in shocked silence. We don't call anyone. At ten we fall asleep quickly, nested like spoons.

I wake up at 3:17, my mind pleading for a diagnosis of anything but cancer. Chris slips out of bed around 6:30. I lie still, as I did all through the worrying hours, curled up, eyes closed, lulled by routine morning sounds of water spraying and draining, and my husband getting dressed.

THE DOCTOR, a small, gentle man, maybe from India, looks me in the eye and takes one hand in both of his, then does the same with Chris. With these simple gestures we become dependent on his competence. It's vital that we trust him, that we believe he is excellent. I need to feel the same way about the nurse practitioner who will take bone marrow samples. She has written age fifty-seven in Chris's record. "He's sixty-seven," I say.

"I'm glad," she says. I watch her replace the five with a six. "Older bones are supposed to be softer, easier to penetrate."

Chris lies on the gurney. I pull a chair as close to it as possible. The treatment room like an oven, hellish, I shed my denim jacket, push up my sleeves, and take his hand. The chatty assistant tries to engage us in conversation, but I'm unresponsive, willing her to stop talking and concentrate on the procedure. She breaks the needle off the first Novocain syringe. She acts surprised. "The BMT is painful at a certain point as it draws marrow from the center of the bone in the upper buttock." BMT is a bone marrow test, medical acronyms a new language to learn. Chris flinches, squeezes my hand, but makes no sound during this barbarous invasion. Reason insists: This test is necessary, it will provide crucial information; information will give us control.

A nurse phones Chris at home: "Your red blood cells and

platelets are very low. You will get two pints of blood tomorrow morning." I imagine the blood of strangers invading his beautiful body. Is the blood supply safe? Could it possibly be healing? The doctor gives us his cell phone number. "Call if you are feeling very weak or bad in any way."

Feeling bad in every way, we hold each other all night, manage to get some sleep, and show up at the hospital on time the next morning. It's April 15, tax day. Riveted on the doctor's well-trained face, we hear him announce the results of the BMT. Chris has Acute Myeloid (Myelogenous) Leukemia (AML). Numbness, disbelief, shock our only response. We stand there, holding hands. What expression is on our faces I can't imagine. My mind is at work on the words: Acute. Myeloid. Leukemia. Acute must mean most serious, crisis stage. Leukemia is a blood cancer, and we know what cancer means. I don't know what myeloid means.

WE'VE BEEN THROUGH THIS once before when Chris had prostate cancer seven years ago, and I couldn't say the word cancer without collapsing in tears, unable to speak, having to hang up on a phone call to the American Cancer Society before getting to my careful list of questions. Chris's response, in contrast, was immediate and clear: "Get rid of it. Cut it all out and do it now." Impatience masking terror, he tried to absorb the explanations from recommended doctors at three hospitals about options that would be less invasive than surgery, but weren't guaranteed to kill all the cancer cells. Chris wanted a guarantee; I wanted him to retain erectile function. To me, apparently, our sex life was more important than his peace of mind.

Waiting for the prostatectomy too nerve-wracking, we decided to spend two weeks bicycling in Downeast Maine. Perhaps punishing the body would cure it. Perhaps exploring an unfamiliar spot on Maine's sharp-edged coast, where pungent mud and rockweed and incantatory sea-slap renewed our spirits every summer, would tamp down fear. On the endless drive the length of Maine to our rental, way past Acadia, past Machias, as far east

as possible, all the way to the West Quoddy Head peninsula in the Lubec Channel, we spoke only about what we were seeing, not what we were feeling.

The small, Civil-War-era cape was wallpapered in fading roses, crammed with smallish framed prints and photographs, ordinary calendar-like images, no breathing space on such nerve-jangling, smothering walls. Tacky, we agreed. Definitely not art. We stayed indoors only to sleep in lumpy single beds in separate rooms. Early each morning we packed a picnic, maps, books, and a sketchbook, and pedaled hard on a different route each day, marking maps and recording each journey — Lubec Neck and all the other Necks, Seward, Leighton, Denbow, and Crow; and the Coves, Carrying Place, Wallace, Hamilton, Julia, and Boot — until we staggered, stiff and sore, barely able to walk. Focusing only on the sights and smells of a landscape we knew we both loved, equally and in the same way. Collapsed on the grass one afternoon next to Reversing Falls, I watched Chris toss in a reversing wish.

We pushed on, crossing the bridge out of the U.S. and riding the length and width of Campobello Island. We toured Roosevelt's home. We ate lobster, clams, scallops, and every other available fresh seafood. In the evenings we listened to a Canadian classical music station.

Optimistic on the surface, accepting and supporting his decision, I buried boulders of resentment, fear, and anger, producing mountains of guilt for being selfish, all suppressed. That was then. We faced that battle and endured, and now, seven years later, devil cancer has once again invaded, slipped through a keyhole into the blood of life.

GLANCING UP at Chris as we pause, side by side, outside the elevator, I press the wall button to activate the wide, heavy automated doors to the sixth-floor oncology wing in his choice of hospital. They swish open and we make a grand entrance down the aisle, my arm crooked in his, past the nurses' station where

many eyes glance up from computer screens at the new people. We keep walking toward the number 6029 on the door of the stark, empty room. We cling to each other, to the delusion that we are impervious to serious illness, certainly to death.

Doctors say his AML subtype is M2. What does M mean? How many Ms are there? Questions accumulate. They have told us the first treatment for leukemia is standard; he would get the same drugs wherever he went. I wonder if this is true. I need to research online, but for now we have decided to trust what we are being told. I defer to Chris's judgment about his body. Perhaps I'm tougher today than I was seven years ago. Perhaps I don't yet understand the nature of this cancer.

We have slipped through a keyhole in the solid door between past and present, health and illness; or rather we have been pulled through it against our will. Now, inside, our forty years together recede into the distance, as if offshore, and suddenly we are in another country called disease whose language we don't speak. Yet. Though I am healthy, I am determined to take this journey with Chris, to bear witness to everything that happens to him. To us.

■ ■ ■

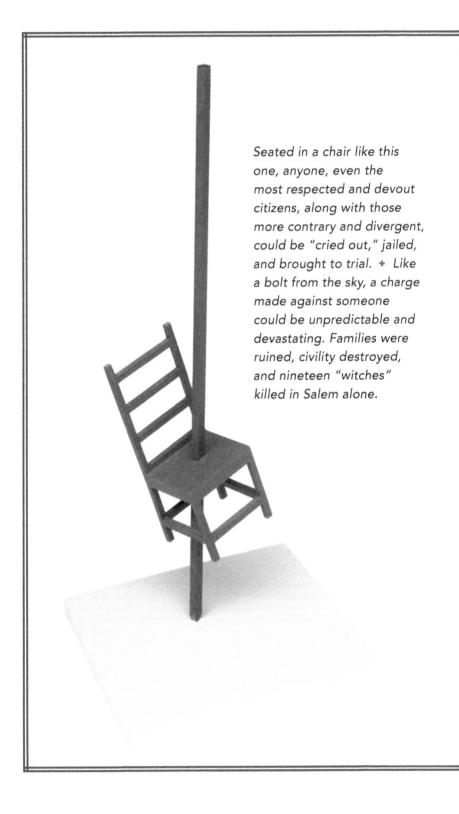

Seated in a chair like this one, anyone, even the most respected and devout citizens, along with those more contrary and divergent, could be "cried out," jailed, and brought to trial. ✦ Like a bolt from the sky, a charge made against someone could be unpredictable and devastating. Families were ruined, civility destroyed, and nineteen "witches" killed in Salem alone.

Accused Chair

April 2004

C HRIS BLURTS OUT, "You'll sell the house!" his head snapping up, dark eyes frowning at me from his perch in bed in the blanched-white hospital room where he is writing about the Accused Chair. I am in the recliner flipping through the *Hartford Courant*. The only color is in spring-greening hills beyond the large picture window.

"What? No, I won't!" What is he accusing me of, wanting to escape our home of thirty-five years? Am I on trial here?

What is he not saying? I'm afraid of dying and leaving you. You will go on living, making decisions without me.

Instead of acknowledging any of this, I feel wounded, yet I can't say he's wrong. Our nineteenth-century Victorian gets more attention from him than from me: his hands putty and paint, strip and sand, pull up floors, and knock down walls. I've often felt burdened by it all, coming home in the late afternoon with a stack of papers to grade, textbooks for planning the next day's classes, and two young, hungry boys. I've despaired from the mess: lumber, paint, and tools strewn around, and plaster dust tracked everywhere as we moved through dinner, homework, and bedtime. But sell it?

Later, again without warning, wrapped in a prosecutorial johnny against white pillows, he charges, "You don't appreciate the deal we've had on renting the place in Maine."

He accuses. I defend. "Yes, I do!" storing his attack to figure out later on my own instead of hammering it out together in the moment. Typical.

Is he forgetting it was all my idea? I found the ad in *Down East Magazine*: $2000.00 for the season, June to September. Did the place have electricity? Indoor plumbing? I decided to email the owner in California, who replied, "If you enjoy the writings of Henry Beston—*The Outermost House* and *Northern Farm*—you would probably enjoy the simple pleasures and natural surroundings of the place." Having read some of Beston years ago, I looked through *Especially Maine* again to be reminded of his beautiful descriptions of stillness, how he had the patience to look and look, despite being nearsighted, and to listen, despite being hard of hearing, to the racket of a rural place one is sure is the quietest place on earth. How noisy water is as it trickles alongside a dirt road. How you can smell the cold, almost taste it, entering an old musty farmhouse that's been shut up in winter. I wanted to go to Friendship, Maine, to smell and listen as well as to see.

I went to work on Chris, selling him a dream that has no soft, sandy beaches; where, instead, a glacial tumble of boulders and giant firs fight for and somehow share scant soil at the very edge of things. Where the sea with gnawing appetite doesn't just nibble, but grabs enormous helpings, great mouthfuls of bank around and under exposed roots, live nerves that run shallow, long, invisible into rock, threading deep where the sea has not yet driven. In nature's chair, her sanctuary in a cathedral of spruce and granite with no evidence of civilization, water wins every confrontation, every time.

He listened, reluctant, skeptical. I was asking him to abandon his studio and the weekly "salon" he enjoyed with artist friends. And just retired, I had begun asking questions about the rest of my life. I was supposed to be free, enjoying a kind of rebirth,

as if all questions could be—had to be—asked again, as if I'd answered them in the first place: Who am I, where do I want to live, what do I want to do? And the question of we: where we wanted to be, what we wanted to do. Living in Maine was a possibility, not just a fantasy. Our rebirth could be truly elemental, a return to the earth, the sea, the sky. Did we want to move there, far from the humdrum? What would it be like to wake up every morning and decide the day's events by temperatures, clouds, winds? Descended from colonial farmers in the "new world," I knew the vicissitudes of clouds.

[May 2002]

ON MEMORIAL DAY weekend, jittery with anticipation, Chris turned his over-loaded red Dodge minivan onto Salt Pond Road in Friendship, Maine, and we descended the hill to our "vacation home," a low, L-shaped structure that looked to be sinking into the ground. Oh dear, it was just a shed!

A roofer's flatbed trailer filled with shingle scraps blocked the front door flanked by an old-fashioned white lilac bursting with buds. A new red roof glittered in the sun. Elephantine leaves curled over mature, pink-green rhubarb stalks in a large rectangular patch, the only sign of a garden. In the carriage shed, parallel to the road, two wide doors hinged open to a screened porch. A room behind and storerooms next to it may have been animal pens and horse stalls. Perpendicular was our two-room "suite:" living room and kitchen, the bathroom off the kitchen. So crude. Ladder-like stairs led to a sleeping alcove under the eaves.

On the kitchen table were pages of notes from the owner: "Welcome to Funky Cottage. The septic is antiquated, flush only once or twice a day; don't let water run down the drain, toss it in the tall grass out back; few guests, at most one or two occasionally. The system can't handle it."

We handled it, I complaining, loudly, as we tackled the living

room, sprayed Resolve on rug stains four or five times, Pledge on everything else. Fortunately, the tiny Eureka vacuum cleaner sucked with vigor spider nests and dust globs under end tables and bookcases, mothballs and turquoise poison pellets under chair cushions.

"This is such a dump!" I groaned. Henry Beston would have had a better attitude.

Chris said in defense, "It's no worse than the Barn ever was," about nearby Flood's Cove, where we vacationed with his family for twenty years.

Funky Cottage was a neglected old camp with saggy couch and musty mattresses and floors that angled with the slope, as if you could skid from the bathroom across the kitchen, around the turn to the living room and out the only exit.

Yet there, as in Lubec, Maine, five years earlier, we spent days and evenings outdoors, away from the place. Chris sat on a rock with his watercolor pad and painted. At some point every day, I took a walk by myself to bird watch and collect one species of wildflower or flowering weed, perhaps a pink lady's slipper, a diminutive white sandwort, or yellow cinquefoil. Or a white clintonia, in the lily family, its delicate narrow petals bursting open at the top of a long straight stem. I stood still before a yellow-throated warbler in a wet thicket, beautiful black mask over the eyes, bright yellow breast, tail flipping furiously to protect his nest. Most days I heard the creaking-door chatter of two belted kingfishers at work between the salt pond and tidal river. At low tide, two great blue herons waited, dignified sentries.

The identifying habit was a gift from my Great Aunt Grace on the hundreds of acres of their Taplin Hill farm in East Corinth, Vermont, where I was born. She knew exactly where and when each wildflower appeared in early spring. When I was there, and I was as often as possible, the Hutchinson farm my favorite place on earth, she untied her full-body apron and flung it on the hook behind the enormous black range, and announced, "Let's go!"

I hopped and skipped to keep up with her as we trekked a

certain pasture to a sunny bank where she crouched and, gently lifting aside layers of dead matter, sodden from melted snow, presented— "Here, look!"—the tender, pale pink blossoms of the tiny trailing arbutus hiding under dark vine-like leaves. She taught me to inhale its heavy perfume, modeling the joy, not once but every spring, of hunting not just the trailing arbutus but all of the wildflowers in turn: Dutchman's breeches, hepatica, may apple, trout lily, and trillium.

Late afternoons in Friendship, Chris and I rode bicycles for miles and miles on curving side roads to the small groceries in Friendship and Cushing, and out to the Olson homestead made famous in Andrew Wyeth's *Christina's World*, now owned by the Farnsworth Museum in Rockland. We drove the length of the St. George and Pemaquid peninsulas, stopping to wonder at a granite quarry or rocky outcropping, at picturesque harbors in Port Clyde and Spruce Head, and the islands dotting Muscongus Bay.

Again accused, tried, and found guilty, I admit I grumped about Funky Cottage on the muddy Meduncook River, kept awake through long nights by red squirrels scurrying behind the bedroom walls like anxieties scratching at my mind. I complained, yes, I did, about our "summer place on the coast" that our grandson called "mosquito house." I gathered real estate ads and fliers, yearning for our own place on the water. Ever rational, Chris applied his clever antidote to the black-fly nuisance I had become: We drove together to the properties I was certain would be perfect. I took one look, "Oh no, that's not it," and crumpled the ads.

Scheduled to return next month for our third summer in Funky Cottage, Chris is complaining that I haven't appreciated it. Why can't you be happy with what we have, he means, but doesn't say.

ALL BUSINESS ON DAY 2 in the hospital, Chris writes a long email to family and friends:

"Did I get leukemia from using auto-body filler on sculpture in the 1970s in my cellar, which is just below minimum radon

measure? Or from rebuilding my studio deck with arsenic-treated wood ten years ago and not being careful enough with gloves and dust mask? Who knows? Smoking?"

He dictates a list of needs: sharpened pencils; disposable razors; a photo of us; computer printouts of two of his paintings, *Amputations Are Forever* (about diamond mining in Africa) and *The Donald* (huge portrait of Trump), and a large sketchbook to continue working on the Salem witchcraft project.

That afternoon our younger son, Toby, 33, in grad school for a master's in landscape architecture, joins us, and we sit like children in kindergarten, spellbound as the doctor draws circles and arrows on a white board in a show-and-tell presentation about blood. "The original stem cells in the blood—there are seventeen—are dormant, mysterious, and hidden. No one knows what they look like." I wonder how they know there are seventeen.

"These stem cells are hematopoietic," he goes on, "the progenitors of all our blood cells, which differentiate as they develop to do a variety of necessary tasks. Leukemia affects white blood cells in the immature, or blast, stage."

No one moves. I may appear to be watching and listening, but the information disappears down my mind-drain. I grab a pen and notebook and take dictation. The lecture continues, "Leukemic blasts are large and sticky. They are greedy, they expand out of control, take up all available space, smother any possibility of further cell development."

War metaphors come to mind: These are terrorist cells. The devil incarnate threatening Chris's life, we must be infidels, accused without trial and attacked without warning.

In sixteenth- and seventeenth-century New England, Native Americans and Europeans intermingled in many ways and for many reasons. For one thing, the two cultures began to trade goods, with the Native Americans being introduced to guns, iron knives and pots, and woolen blankets. Such trading created a powerful dependence on European goods, and this began the acculturation process. Native Americans gradually lost many of the traditional skills that had allowed them to survive and even flourish in the harsh New England environment for hundreds of years.

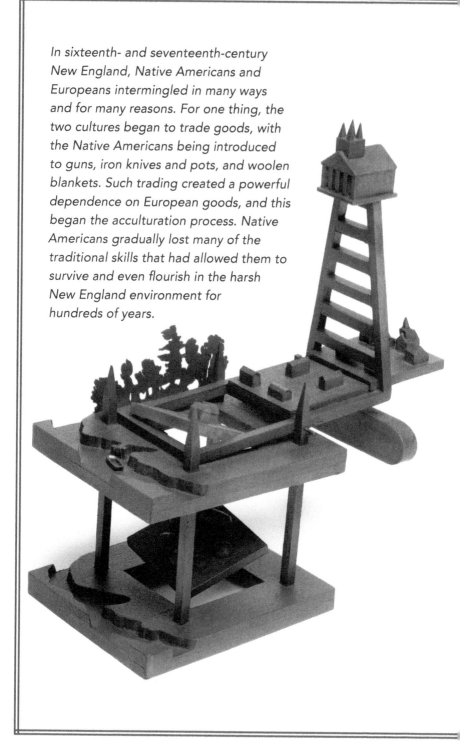

Cultural Displacement Chair

April 2004

C HRIS WRITES in his sketchbook:

April 22. Thursday. Foggy but another day!
Small resolves:
1. Stop swearing.
2. Don't start talking to myself out loud.
3. Leukemia is freeing me. Suggesting what to think,
how to pray, especially to be grateful, so much to fill
me with gratitude for God.
4. I can take each new morning and day with full
peace and pleasure. I need no more. Many projects
I can continue on (Esp. SALEM WITCHCRAFT). But
even if they are never completed, each day of work is
tremendously rewarding.

Number one makes me laugh: I have never heard him swear or
pray or use the word pray. He always says he is agnostic. I do
recognize and admire his disciplined commitment to making art.
He seems to accept all of this, sitting patiently for a third blood
transfusion in as many days. I go to the Red Cross headquarters

down the street and learn I cannot designate my blood for a specific person. I can contribute to the general supply if I pass the 100-question test. I do and lie down on the table. I watch my universal type O flow into a hanging plastic bag, as tears flow. The attendant glances at me. I look away. I need to wear a public face in this new world.

Back in the hospital room, I stare at Chris's ankles, as swollen and smooth as inflated white balloons, translucent as jellyfish. He looks at things our older son, Josh, newly married at thirty-five, dropped off on his way to his law class: stories written in elementary school, a CD of Beethoven's Ninth, and a bag of truffles. Since Chris can't have chocolate, I snag the truffles for myself. With a weakened immune system, he is on a neutropenic diet to eliminate as much bacteria in food as possible. No deli meats, no salads, no raw vegetables or fruit. Canned fruit is okay. Everything he eats must be cooked to mush, the opposite of our preference for crunchy vegetables and salads. We must adapt.

In the small notebook I carry are many to-do lists: Take a multivitamin; Buy a hand sanitizer and everyone use it; Don't take vitamins with strange herbs.

Chris calls early the next morning. "Bring in your laptop, okay? I want to work on the Salem chairs. Also bring the hair-cutting scissors."

As he concentrates on the text for the Cultural Displacement Chair, I list the names of people who have called and sent cards, savoring the energy in their words, the time they spent thinking of us. Sick families need, and receive, a lot of attention. My mind takes a turn toward blame. Is my neediness or my resentment or my negativity — or any of the awful things about me — responsible for Chris's cancer? If I can't control my world, I must have done or believed something wrong. This thinking is puritanical, isn't it, as if everything that's happening is my fault. An inherited world view. I feel crazy thinking it.

Trying to exert some control after more than a week in the hospital, Chris becomes particular about how he will spend every hour of every day. Fussing about the timing of his shower, he

decides to take a sponge bath around 7:30 and asks me to wash his hair. I smooth liquid soap over the blotches on his scalp and rinse it with lukewarm water from a plastic cup. If only I could wash out these purple stains. I study his face, the shine in his eyes, his pinkish skin tone. I stare at the beautifully shaped hands of an artist, his long, symmetrical fingers. Hands that have meant stability and security for me. Loving hands.

I'm told I have to be alert to minute changes in his condition. I'm told I know better than anyone what's normal for him. The word normal triggers a small, ironic smile. I'm told that the skin blobs on his scalp are called chloromas. It's unusual for them to be purple; they are usually green. So why are they purple? Hiding under his hair, these rather expressive shapes look as if an artist's brush — or devil's hand — has painted them on the skin's canvas from the inside.

A LOVING FATHER EMAILS his two sons ten days after being diagnosed with AML:

> I can't help thinking of you guys as I undergo this very "focusing" experience. Mom and I are just so proud and pleased with your love and steady movement through life. You both have taken many, many kinds of steps and jumps and leaps and stumbles and falters. Each and every one shows us something, teaches us how to grow. Whatever happens, take each hour and day as a piece of great fortune and work on it well and with respect. Please remember each small step and act and moment contributes greatly to the whole. Love, Dad

Chris says he feels woozy but clutches the IV pole anyway, shuffling along in his slippers every morning and afternoon as he does two or three dozen laps around the nurses' station. He estimates the number of miles he has traveled. I keep his pace for

a few rounds, his left arm locked around my right elbow. He talks about one of the nurses who told him she loves his watercolor of a Friendship shoreline. The blank walls of his room are now alive with figure drawings and landscape paintings. "She said she doesn't like the way I painted the water. It's funny," he laughs, "everybody's an art critic."

I am not. Unlike others who admire his finished watercolors in soft grays, greens, and blues, I am more aware of the weeks each painting takes, the attention to detail, the painstaking effort to represent every minuscule chink and hue in a huge granite boulder. When we're in Maine I watch my husband wave — "See you later" — as he launches his Mongoose mountain bike at the same time every day to begin the four-mile trip to a waterfront site to capture light falling on rocks. Backpack loaded with paints, brushes, water jar, paper towels, sunscreen, snack; folding canvas stool and large watercolor pad strapped onto the bike-rack behind him; sunhat and sunglasses shading his eyes. He bears down on the pedals, leans over the handlebars to tackle the steep uphill just beyond Funky Cottage.

Today, woozy or not, relieved to be back in bed, he dictates a to-do list: Dodge minivan needs servicing; bring socks, electric razor, post cards, and address book; offer the van to Josh or Toby.

I freeze. What? To borrow? Does he think he'll never drive his car again? I nod, keep my head bent over the list. He's rational, practical. I swallow fear, don't follow through.

CHRIS IS WRITING questions for the doctors. I'm sitting close to him on the bed in a bullfight-red sweater, my first ever, fuming about the time it takes to find out anything, frustration the IV fluid coursing through my veins. Today, we're waiting for the report on his cytogenetics, a test that shows specific damage to genes, damage that everyone apparently has just from living in a particular environment and from what is called "lifestyle." He leans into my shoulder to get my attention. "Last night one of the

oncologists hinted that the results are not good." I don't want to hear that. I say nothing.

Our scheduled 10 A.M. meeting is delayed. 10:30, and no doctor. We wait. Finally, around noon, four doctors circle Chris's bed. One stands close to him, looks into his eyes, and explains in a soft voice, "The cytogenetic report on your bone marrow shows the third level of destruction, poor. Poor means your stem cells can't produce new, healthy blood cells. Poor means standard treatment is unlikely to cure your leukemia."

We stare at him; he does not glance at me. There's no sound, not even a peep out of an IV monitor. The only thing moving is the doctor's mouth. "There aren't good treatments for you, and your particular genetic abnormality, monosomy 7, is prone to infection." He takes a breath. "There are various transplant approaches. The classic way is allogeneic, transplanting cells from a sibling whose blood characteristics match yours."

"My brother Tim is ready to have the test," Chris contributes, his eyes locked on the doctor's.

As if he didn't hear him, the doctor continues. "There are a variety of hurdles to overcome. The main barrier is age. And transplant is not the only option. There are newer approaches, lighter forms of therapy. Specific drugs can target specific genetics."

Despair. You have the worst prognosis.

Hope. You can have a new kind of therapy.

Chris's response to this news is to talk about something else: art, not illness. Before any of us can discuss these options and decide what to do next, he reaches for a folder on the bedside table and pulls out 8 x 11 color printouts of his painting about African blood-diamond mines, *Amputations Are Forever*. This is the conclusion of the two-paragraph text that hangs on the wall next to the painting:

> *One company, DeBeers, with massive advertising campaigns, has created a belief in and market for diamonds like no other commodity on earth. Conflating promises of eternal love and assured increase in value, DeBeers' slogan, "Diamonds Are Forever," has become*

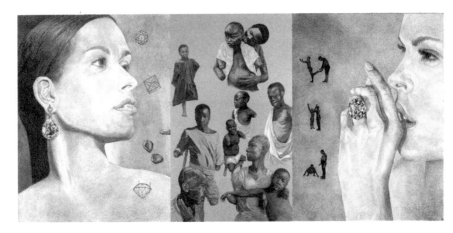

Amputations Are Forever, 2001. Approximately 8 x 5 ft.
Acrylic and mixed media on canvas on wood frame.

*the mantra of the industry and a chant on the lips of its
fully conditioned consumers.*

I watch these doctors, "fully conditioned consumers" of
diamonds, no doubt, as they listen to Chris talk about the piece.
They say they want a copy, and he signs and hands one to each of
them. I crack a smile at this ceremony. It's typical of him.

Since the 1980s he has produced enormous paintings about
masculinity and power in business, politics, and sports in
contemporary life: football, which he played; monstrous portraits
of Freud and Donald Trump; and many other large acrylic
paintings about Wall Street, the Middle East, Africa. When he
finished *Amputations Are Forever* three years ago, he declared
it was his last big project — "such depressing stuff and the toll it
took." Since he rarely mentioned the emotional effects of making
art, I remember the weary certainty in his voice. I wonder if he
was anemic even then. And yet here he is, in the hospital, taking
up another painful historical moment in seventeenth-century New
England that resonates with the challenges and failures of powerful
patriarchal institutions.

After the doctors leave he closes his eyes and naps, refusing to acknowledge, today or any day, his own physical condition or emotion. He's all intellectual artist, the professor controlling the conversation as he's done in front of classrooms all his life, as he's done in our family.

My mind, reeling, loud in the silence, takes off in the only place it can, and I sit where natural light hits the pages of my notebook. I write eulogies. I rebuff friends and everything loved in the past, Maine especially. I won't escape there to meander paths and shoreline, won't reprise thirty years of contented hours. No nostalgia. I imagine joining the Peace Corps. I won't settle. No condo in an adult community, no assisted living. I use the past tense: I loved this man for his intelligence, his passion for art and commitment to teaching. Alongside the unhealthy habits, the smoking and drinking he kicked a few years ago, was someone I trusted and admired, the kind of person I wanted to be.

Later that afternoon, after his nap, we nestle side by side against thick pillows. I lean into his chest. His arms around me, Chris says he is grateful each morning to wake up and look out at hills and trees. We say we are grateful he is feeling okay: good appetite, normal functions, and a clear head able to think, read, and write. Grateful is what we say we are. Grateful just isn't everything we are. I don't know if he is furious — he won't say — but I certainly am.

I retreat to our old house on Lovely Street, let it wrap its arms around me, alone in a space that reverberates with maleness. Where Chris, with volunteer "whack-'em-up" crews of skillful friends, improved every system and surface, ceilings and floors, kitchen, bathroom, laundry room, roof, even the large barn where he added a second-story art studio and deck. Where in the living room he painted a huge parabola — bands of yellow, blue-green, rose — on the old pine floor we couldn't afford to carpet or replace. Where Toby, in the 1980s, teenage angst consuming him, exercised artistic license on all four of his bedroom walls with an assault of nightmarish images: huge black bombers, mushroom clouds, and illustrations of Pink Floyd's *The Wall*.

Every room a museum: the grandfather clock, Mother Horton's hooked rugs, the hand-me-down lamps and sofas. And the Windsor chairs, their curved arms and spindle backs containing the broader story of our English ancestors. Small rock and wood sculptures and wooden boxes filled with stones clutter the floor. In the bottom of an enclosed cabinet above the bay window in the living room Chris drilled a hole large enough for the end of a stone to protrude about six inches. And there it hangs, showcasing his sense of humor and generating questions — what is that stone doing there? — every time someone glances toward those windows.

Somehow I sleep and wake up in silence. If I don't get up, perhaps I don't have to acknowledge what's happening. How can this be happening? Too soon, too soon! Panic flooding my chest, I force myself to breathe out, empty, pause, breathe in — one two three four five six. Focus on now, not the end of the day or the middle, but the small moment-by-moment things. Pick up my jeans and underwear and toss them in the laundry room. Unlock the door, walk out to the street for the papers. Check the mousetrap. Make strong French roast coffee. Type and print the draft Chris is working on about the four-poster chair.

At the hospital I arrange the get-well/thinking-of-you cards on the windowsill as I do every day. When I leave the room, he tucks them underneath his sketchbook, out of sight. The first time I noticed they were missing, I assumed he had thrown them away, but neatening up I found them. We continue playing this game: I display good wishes from others; he hides them. Today, sitting back in the La-Z-Boy, Chris tosses another grenade from the past, this time about "putting you through hell those four years." Oh my, now he's remembering our summers at the Cummington Community of the Arts more than thirty years ago!

All I do is mumble something like, "It was my fault, too."

He changes the subject, and I'm relieved. He asks me to find books by Kahlil Gibran and Thomas Merton, then disappears into the lunch menu and orders in minute detail chicken noodle soup, two cheeseburgers with fries, four catsups, coffee, eight ounces

of two-percent milk, fruited yogurt, vanilla cake with icing. For Sunday breakfast he'd consumed French toast, a ham and cheese omelet, cereal, two coffees. No problem with his appetite!

Summers in Cummington. I don't want to remember. But why not, after all this time? Why not grab the moment and go to him, sit up close, look into his eyes, eager to know what he's thinking about that period in our lives? I can't. I don't. I shut down, unable or unwilling to trigger explosives buried in the minefield of a long marriage.

April 29

ANTICIPATING HIS DISCHARGE tomorrow, I begin a "No Dust" regimen at home and ask a young neighbor to help me clean. It's up to me to purify this drafty old house where ancient microscopic creatures surely lurk. I put miscellaneous junk on the bureau out of sight and fold my father-in-law's wool cardigans I wear all winter in a pile to be dry-cleaned. In a never-opened drawer I find eight empty, velvety jewelry boxes and give them to my neighbor for her daughter. Cousin Debby calls, wants to clean, bring food. Susan calls. Anne calls. Everyone wants to help with whatever we need.

Debby brings a dozen startling daffodils and a four-berry pie. My sister Lorraine and her husband Bill come to clean woodwork and window shades. I yank the staples out of the wool stair runner Mother Horton hooked, one that I love, each tread a large rose in soft pink and lavender on a pale green background, perfect in a Victorian house. Piling them in a plastic bag for storage, I send her deep, silent gratitude. Josh stops by to help me get rid of the room-size carpet in our bedroom. We cut it into pieces and stuff it into a trash bag, also the pad under it, much of it crumbled to yellowy dust. I scrub the old pine floor, despairing of cracks between the boards that have widened over the years. Those interstices again. What hides there? I imagine all the emotion, the disappointment, joy, guilt, all the microscopic slough of touching having settled into the

old floor. I wash load after load of curtains, blankets, mattress pads, and bedspreads, and the dishwasher runs at the hottest setting. If I weren't so nervous, this whirlwind would be funny.

In the hospital, Chris holds onto hope in emails: "THE PLEASURE OF MODERN MEDICINE: One feels absolutely fine, while still being very sick! My own mortality seems at hand. One way or another, though, I have yet to look squarely at it."

Instead of looking at mortality, we write questions about discharge: Can he breathe normal air, go outdoors? Can we open our windows? Can he climb stairs? What are the signs of infection? What does "clammy skin" really mean?

No sleep that night. I get up at 3:00 A.M. and make hot chocolate, which is delicious and settles my gnawing stomach, likely from the mound of raw spinach I ate for dinner. I settle into bed in Josh's old room, quieter than ours, and open Caroline Morehead's *Gellhorn, A Twentieth-Century Life*, a just-published biography of the pioneering journalist, my friend's Aunt Martha. I skip to the section about her experiences in World War II and read that after visiting Dachau, the terrible knowledge left her unable, ever again, to have an optimistic view of humanity.

While she was intimidating in person, I've long admired her as a writer in the middle of the action in every war in the first half of the twentieth century, breaking new ground in her insistence on direct experience. She was the only woman who did, a beautiful woman willing to rough it, charming soldiers into letting her ride in a tank to the front. I think about how her commitment to journalism, among other things, ended her brief marriage to Hemingway. I fall asleep around 4:30.

8:00 A.M. — Chris calls using his reporting voice. "The doctors will be in sometime after 2:00 to report the results of the bone marrow test."

5:00 P.M. — No sign of doctors. I've dozed all afternoon in the green vinyl chair. Chris is subdued, focused on the infected spot on his left ankle and the painful rash on his back. It's Day 15 in the hospital. How can the sun be so bright, the trees so newly green.

8:00 P.M. — The doctor arrives. "Our preliminary look indicates

there are eight to nine percent blasts (leukemia cells) left in the marrow. We will need to give you further treatment."

We feel the slap of defeat but can barely react, depleted after waiting six hours for him to swing open the heavy door, our heads snapping up every time a nurse breezed in to change a medication or a technician to take his vitals. Some kind of reinduction chemotherapy will start Monday or Tuesday to destroy the remaining blasts. The end of April, the cruelest month. T. S. Eliot got it right.

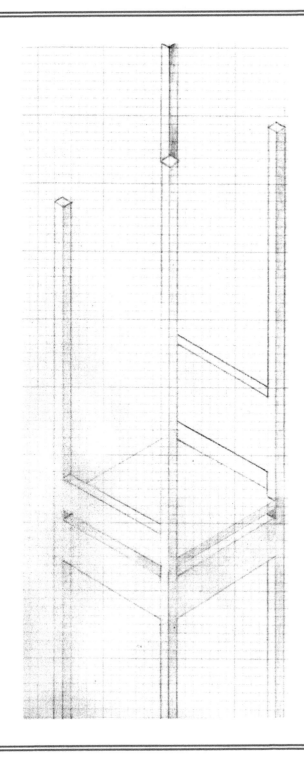

Four-Poster Chair Design

May 2004

HURRYING TO ROOM 6029 and Chris's bedside, I lean over to kiss the top of his head. I get a frown for a greeting. No smile, no hi, how good to see you. "This afternoon has been so frustrating, not five minutes without someone fussing over me. I haven't even finished writing about the chair that will look like a four-poster bed. Will you read what I have so far?"

"Sure." I lift the computer from his lap and move to the recliner. As first reader, I'm in my element.

> Someone could wake up in bed any time with a cat, bird, imp, or other strange creature sitting on the footboard and lurking about the bedclothes, making overtures from Satan. A large ugly specter or familiar could appear sitting on one's chest, suffocating and choking the life out of the awakened sleeper in order to force him or her into the arms of the devil. The abode of love, conception, birthing, dream, rest, memory, and recuperation was no longer a sanctuary and haven, but a nightmare battleground fraught with evil and fear.

Oh dear. He insists on focusing on history, not this direct experience, suppressing with metaphor his own loss of rest and, yes, loss of love and dream. I say only, "It's good. Keep working!"

Later in the evening I am lying on Chris's bed, having usurped it. I become the strange creature, as if I were a specter whose mission is to remind us of the threat we now face to our "normal" relationship. He pulls a chair next to this "nightmare battleground," sits down and takes my hand. We share a moment of quiet commiseration, his warm, brown eyes and my hazel eyes tear filled, gazing deep. A rare letting down for two stoics.

The next day an energetic Chris emails our distribution list of family and friends: "My spirits are good. I am greatly cheered by all of your thoughts and cards and the Art School care package. With this second course of chemo I'll soon see my ugly skull and weak chin I've hidden all these years. Sherry is my guardian angel and we are working to beat this thing together."

We examine the silver-dollar-size infection on his inner left ankle and remember the misdiagnosis of psoriasis in Maine two years ago, when both ankles swelled with a red, scaly, oozing eruption. He finally went to a doctor. I don't know whether he took a blood sample or biopsy; most likely, he did neither. I wasn't paying attention. "He just said it's an infection and prescribed an antibiotic," Chris reported. The swelling gradually went down and the skin healed. It took months.

I continued doing what I did every day in Maine, collecting details in a notebook of warblers and lupine, the wind-tide connection, the slant of light through a window at a certain time of day. I witnessed details of mood and nuance between two people. I thought about what it meant to spend four months away from home in a place of can'ts, where I couldn't spend real, physical time with my mother or sister, or walk or have lunch with a friend. I missed the face-to-face knowing that's more intimate, more satisfying than news delivered in phone calls and emails.

Because of a guilt dream I vowed to stop inundating Chris with ads about waterfront properties for sale. He wasn't interested, and continuing to remind him of my fantasy upset him. I always

wanted something else, whether it was my house, my job, my husband, or my self. Why couldn't I enjoy what we had, a dream come true to spend an entire summer on the coast of Maine? No, I wanted a place of our own. While affordable, the one we had was not perfectly situated in relation to sunrise and sunset or in relation to water. Water should be seen and heard from every window.

This evening, unannounced, unscheduled, a dermatologist sweeps in at 6:00 to take tissue samples from Chris's ankles, interrupting his dinner. He complies and lies back, pulls the sheet off his legs. She dons a protective mask, clear plastic eye shield attached to a nose and mouth guard, the specter of a Hazmat worker hovering over his bed. She numbs the ankle, takes the samples, and deftly knots two stitches. "They might not hold because the skin is so taut, stretched from swelling."

Again I remember his ankles two years ago. What if we had been more assertive then and unveiled the cellular breakdown early enough to have been treated before it worsened? Anxiety rising in my chest, breathless, drowning, I reach for a notebook and escape to an oasis of thought.

What does it mean to write everything down? Words arranged in a sentence create a fiction. Another arrangement of words on the same topic using some, but not all, of the same words creates a different truth, another fiction that language delivers, mutable, never fixed.

This juggling of words is further complicated by an attempt to write history, which is assumed to consist of "truth," stated as "fact." Yet, a writer can never truly access the mind of a historical figure. A moment in the past, stuck there, seemingly immutable, changes as the remembering mind moves into the future, reinterpretations shaded by contemporary world views and experience.

A good example is Hannah Dustin, whose reputation has shifted over time according to scholars, mostly male, who have made their case for the meaning of her story, perspectives shaped by dominant world views of womanhood in their own time, each successive "reading" of Dustin somewhat different from the last.

Even when a writer is aware of other perspectives that might have influenced him or her, and one by one peels them away, each with its own entrenched way of "seeing," the core experience remains elusive, as ephemeral as a second, a shutter click. It is an exhausting effort to inch up to a moment that has passed. I want to come as close as I can.

Rereading this journal entry, I recognize the cultural studies theory I taught in freshman comp classes from a textbook, co-written with colleagues, titled *Reading Our Histories, Understanding Our Cultures.* It's become a habit of mind, natural for me now, to examine multiple perspectives of every situation, including the seventeenth-century witch story, the story of my eighth great grandmother, as well as the story of our late twentieth-century marriage.

[*1968-69*]

BARELY TWO MONTHS into our first pregnancy, Chris celebrated by presenting me with a tandem bicycle. "We can do this together," his voice proud. "I'll provide pedal power!"

"Sweet," I replied, sarcastic. "I'll ride with a view of your back and you will see where we are going." He returned the bicycle. It was spring, 1968, and we were both finishing a year of teaching. My first year of teaching junior English at Conard High School would be my last, for a while. Chris was completing his first year as assistant professor of art education at the Hartford Art School.

At that time, the late 1960s, the whole terror-filled world seemed threatened with annihilation from multiple assassinations, nuclear-weapon proliferation, and a protracted war on the other side of the world. Watching the Vietnam War explode on TV, we were still sticking to our agreement to start a family after three years of marriage. That said, the decisions facing our slightly younger contemporaries, whether to enlist and fight in Vietnam or run to Canada to avoid the draft, also concerned us. Since Chris had

already served in the Army, we had the opportunity to be inspired, like many others, to create an alternative way of life — to search for some local, personal peace.

Chris's idea was to return to the Cummington School of the Arts in the Massachusetts Berkshires, a fifty-year-old summer school on two hundred acres where he had taught painting in the early sixties and where we had honeymooned three years earlier. He wanted to transform the faltering school into an experimental artists' community, something between a commune on the left and a traditional school on the right. Eager to enjoy summers among those rolling fields and hills where there was no level ground, I agreed it would be exciting.

He applied to the Cummington Board of Trustees, and in January 1969, when our firstborn was two weeks old, we drove the snowy turnpike to Boston for an interview. I sat on the floor outside the boardroom and nursed baby Josh. When he slept, I tiptoed in to hear the discussion. An intense Chris was talking about how unique the new community would be. "Artists don't need to be completely self-engrossed. They can recognize the interdependent nature of creativity. Imagine it!" he commanded, trustees' gray heads nodding. "Three dozen artists living and working together for an entire summer, not just a week or two."

Back to the land. Living with love. It was heady stuff. Did it sound like peace? By the end of January, the Cummington Board had hired us as co-directors. Delighted with this new challenge, Chris began the spring semester at the Art School, and I endured the winter in rural isolation, often snowbound in our three-room apartment in a country barn, not seeing anyone for days.

Though sleepless in our ornately carved four poster, our "abode of love, conception, and birthing," with a colicky infant and a breast infection, terrified and alone, alone, alone in my role as Mother, I assured Chris I would help plan the new community. I always wanted Chris to do what he wanted, never imagining where it might take him, and us. Living in a community would at least end my feelings of isolation, wouldn't it?

What would be my role? Caught between the revolutionary

self living in an artists' community and the conventional self taking a husband and bearing children, where could I stand without tumbling? In the 1960s and '70s, there was no obvious route or solid ground. Get married in an open hayfield or in the Congregational Church of my childhood? In 1965, I had chosen a church wedding to please our families. Or did we both choose? Back then, did it matter to him? And in the midst of 1968's global chaos, we dared to start a family, a natural-enough decision and one that changed everything.

Who were we then? Chris was self-assured, knew what he wanted. I was one kind of woman, loving wife and mother, and teacher, wishing I were another kind, a free-spirited artist. My necessary attention to mothering did not seem as interesting to him, nor did it seem—it has to be said though no one said it—as important as the new community he was building, traveling the region to recruit artists, musicians, writers, film makers. Having a family was a sideline for him, not the main event; art was the main event, teaching art, making art. It was his life and I knew it should be mine, wanted it to be mine, but I couldn't do it all.

I was first a mother, and my commitment to that role took everything I had. Any other dreams were on hold, though alive deep inside me and my notebooks. It has taken the rest of my life to admit the depth of unrealized ambition, to say, writing now, witnessing now, that I've come to accept, or if not exactly accept, at least to have some compassion for that young woman.

[1969]
Cummington Community of the Arts

I REMEMBER the old green wicker chair—rickety, rain-soddened thing—at Sunday afternoon concerts in the Music Shed. I dragged it back behind rows of chipped, red-painted pews teetering on uneven ground and propped it next to the stonewall bordering a deep, dense wood. There I could focus on a Bartok trio until

six-month-old Joshua fussed and I scooted, shushing him, back to the nursing rocker in our bedroom, loathe to disturb the faithful audience of Cummington villagers who had attended weekly chamber concerts there since the 1920s, and still attended, curious, no doubt, about the new folks.

That was every Sunday afternoon. Weekdays, the Community felt insular, and it was, until events beyond the school's two-hundred acres roared in like sudden electric storms. After all, 1969 was the summer of Woodstock and the first moonwalk, travels to both inner and outer space. On the evening of July 20, a dozen or so of us gathered on the Frazier House porch to witness the moon landing on a tiny black-and-white television, families cuddling on the floor, children allowed to stay up late, heads leaning toward the snowy screen, awe struck. As Neil Armstrong pronounced a giant leap for mankind, college kids wandered in and out, giggling. Their behavior presaging a kind of leap Armstrong likely did not intend. One mother asserted later, "They're always high on something, don't you know that?" No, nursery bound, I was naïve about whatever went on down the hill in the barn-dorm where students lived.

In August the Community debated in a long meeting the question of whether to go to Woodstock, and the gap between younger unencumbereds and parents with children widened to a chasm. Chris, father figure at 33, stated that some having a life-changing experience others did not might split up the community. I didn't have a strong opinion. If they wanted to go, why not? The naysayers, like Chris, were parents in their thirties whose younger selves might have sought out that adventure. In the end, a dozen or more "kids" piled into cars and took off for a farm somewhere in the wilds of New York State — how did they know where to go? — leaving the rest of us feeling rather abandoned, yet unwilling to expose our young children to whatever unpredictable experiences awaited those who braved the huge rock concert.

May 10

ON THIS DAY, our personalities are opposites, like inflated and deflated balloons. Chris reaches out; I shrivel. I feel more expansive only in yoga class, executing precise moves as the instructor's voice guides body and breath: "Inhale, right foot back, left foot back in a downward-facing dog, exhale." Otherwise, my mind has been stolen. I can't read anything meaningful, like online research about AML that I want to know but I can't absorb. I want to escape, and I struggle to resist drinking more than a glass of wine or two with dinner, self-medication so tempting. Eating right also takes effort. Why not finish the whole bag of chocolate chip cookies? I have been spoiled by years of balanced evening meals that Chris prepared, his way of welcoming me home after work five days a week. Another void, a stale kitchen in a house heavy with absence.

In the early morning on Mother's Day, I tiptoe downstairs where slant light does not yet strike the four skylights in the kitchen. I glance out of the window at the three tear-shaped garden beds now free of maple shoots, and turn to ritual: grind French roast beans, wash five strawberries and slice them onto organic Heritage Flakes, then prep for the trip outdoors to retrieve the *Times*—remove robe, pull on sweatshirt, tuck nightie into sweatpants. One must be presentable to the traffic speeding down the hill. I remember Chris admonishing me in his father's proper voice, "Why do you insist on going out in public in your nightgown!" And how I'd smirk at him and do it anyway.

After breakfast I sit outdoors with the Sunday papers on a sharp new morning, the combination of a light mist that fell overnight and a warming sun drenching me with the rich perfume of lily of the valley. It's a favorite of the three "Valley girls," Valley my mother's maiden name. I smile at this memory. I try prana-breathing to the rhythm of a mourning dove's cooing, but its inhale is too rapid, quick sips then a series of three exhales. I can't keep up with it. Josh and Toby, still sleeping at 9:00, are upstairs in their childhood

beds, abodes of dream and rest. And nightmare battlegrounds. Our boys. Their whole lives in this house.

When I visit Chris later in the day, he is standing in front of the mirror wiping his face and neck with a warm, wet cloth, soft pink cheeks and chin now visible beneath his thinning beard. His scalp shows through in places. He will lose all of his hair from chemo this time, helpless to prevent it, rather than deliberately cutting it to perfect a Halloween costume. Since he is off all IV medications after the second course of chemo, no nurses or techs interrupt us. Careful voices on *60 Minutes* discuss the war in Iraq.

The only other sound is the quiet whir of Chris's "familiar," the haunting presence of the CPAP breathing machine he has slept with every night since a diagnosis of apnea several years ago. By 7:30, disguise in place — mask covering nose, cap over skull, tube connecting mask and mouthpiece — he has descended to airy depths. Sitting here with him, I realize something about my husband. He never disobeys doctors' orders or refuses to take a single prescribed pill. Whatever the diagnosis, he does what he is told, accepts authority, in stark contrast to the critique of power he has always brought to his art.

May 15

THESE PAST FOUR WEEKS of spring were New England's finest, yet here we are in an air-conditioned cell, guilty of something — what? — tried and jailed on the sixth floor in the oncology wing. Abu Ghraib. Humiliation. No exit. Every day I drive back and forth with the sunroof wide open as if I were free.

Chris's favorite night nurse tells me, "Your husband said he is tired and wants to go home." What did he mean? Does he want to stop treatment, come what may? I don't ask him and he doesn't say anything to me. Another vital topic swallowed. But perhaps I am overreacting and he just wants a break from the hospital. Who doesn't?

If only I could have absorbed, then, the wisdom of Dr. Sherwin B. Nuland in *How We Die, Reflections on Life's Final Chapter*, especially the chapter on "Hope and the Cancer Patient." At the time, I was able to concentrate only briefly on a paragraph here and there. Now, I see myself in his words: "No one who has treated cancer patients will ever discount the power of the subconscious mechanism we call denial, which is both friend and enemy of a person seriously ill. Denial protects while it hinders, and softens for a moment what it eventually makes more difficult." In our case, I think the denial was all mine, not Chris's, who seemed from the start to be able to accept the reality that his addiction to nicotine probably brought him here. I see now that denial probably drove my suppression of everything in our marriage. I thought I was supposed to be able to handle everything on my own.

The nurse preparing us for discharge teaches me how to change the dressing over his catheter: "Dip a cotton swab in Bacitracin and trace a circular path around the insertion, starting at the center. Let it dry a minute and repeat two more times, moving away from the insertion, careful not to go over the previous circle, which would contaminate it." My hand shakes.

Friday — Relieved to be home waiting for Chris's immune system to crawl back from chemo destruction, I rake and weed, spending more time outdoors than I have in a month. Chris, also energetic, strides up and down the long driveway both morning and afternoon. We read a chapter in *Wolf Solent*, John Cowper Powys's 1929 novel about one man's spiritual journey, amazed at the psychological intensity in the careful descriptions of everyday streets and shops. Chris had just finished *A Glastonbury Romance* (1932) and wanted to share another Powys novel with me. This was our idea of fun.

I don't know why he had read *A Glastonbury Romance*, perhaps intrigued with the Arthurian legend because we'd been to Glastonbury, England, with students a few years earlier when he taught an art history class at the Bristol Polytechnic. Or because, as Margaret Drabble writes in a review, "In Powys, the contemporary is ancient and the distant past is modern. Time is interwoven, and

epochs coexist." The author's perspective on time and history is familiar to us. It's what Chris deals with in his artwork, what I taught in first-year writing courses.

Reading *Wolf Solent* aloud, we laugh at the Gothic descriptions in a few moments free of debilitating worry and fear, but we don't get far. Chris's energy flags over sentences that are too dense, and when I take over reading, he falls asleep. We're unable to recreate the same enjoyment we felt before we were married, when, after sharing a tuna casserole topped with crushed potato chips, we lingered at the kitchen table in the apartment I shared with my friend Bunny. Stalling Chris's departure and the inevitable paper grading that awaited us, we read aloud from the first Gothic novel, *The Castle of Otranto*, by Harold Walpole, who claimed to have created a completely new form that blended fantasy and reality. I remember how we giggled over the eighteenth-century style of writing.

Tonight we climb into our "abode of love, conception, and birth" and hold on. One more day.

Monday — Everything falls apart. The ankle infection returns, and his nose streams blood during the night and all morning. In the afternoon we spend eight long hours at the clinic where his blood is drawn and, because levels are low, infused with a wonderful-someone's hemoglobin and platelets. The doctor tells us that Chris's immune system is shot. "Now is the nadir," he says. Yes, indeed, from Sunday peak to Monday abyss. We leave at 7:30, cranky-tired.

I indulge in a silent rant: Where in hell is the housekeeper who cleans bathrooms and mops floors? The technician who takes vitals and measures urine? The nurse who flushes lines and changes dressings, brings the correct medications? Where is the nutritionist who follows the neutropenic diet and the chef who delivers the correct food: three desserts, three beverages, two veggies, meat and soup? Here I am!

Tuesday — We learn at the clinic that Chris's ankle rashes are not staph infections, but vascopathis caused by leukemia. Oh dear, is that what he had two years ago? He's had leukemia all this time?

Every day the thermometer reading threatens his time at home. We frown at each other and look at the clock. I am the one who must walk to the bathroom and get the thing and stick it in his mouth. Our anxiety around taking his temperature colors, no, ruins the precious days, though we don't use or even think the word precious. We feel we are owed normal everyday days, like everybody else, to enjoy spring doing normal spring things.

Wednesday — Fever at 8:00 P.M. Back in the hospital after just five days at home.

Thursday — Around 8:00 A.M., the appointed hour, I drag myself into the noisy, evil room by the main door, where carts rattle and people chatter day and night, and stop in my tracks at the dark expression on Chris's face. Barely greeting me, he launches into an account of his morning, how after breakfast he'd looped the nurses' station. "One lap felt fine, then on the toilet I started to feel woozy. My chest tightened and my heart started racing. I made it to the bed and pressed the button for help." I stare at him, incredulous. He's talking so fast I don't interrupt. "Four or five doctors flew in, but then both a nurse and a technician — you know them, Sandy and Dan — saw the resident cardiologist use a regular needle in the line, puncturing it, and blood starting to come out, which could have opened the line up to bacteria that could have quickly infected my heart."

And he races on, "The same resident then ordered 0.5 milligrams of a medication when 0.5 micrograms was the correct amount. If Sandy hadn't caught it, it could have killed me! They tried three times to get my heart into rhythm with meds, including one that gave me a big jolt but didn't work."

Mouth gaping, I don't have time to say anything before our favorite techie hurries us to the quiet room at the far end of the unit. He drags in a La-Z-Boy and a table for books, and hangs clothes in the closet. Order restored. He turns to Chris, "Got everything you need?" Got life!

Despite all that has happened in this nightmare battleground, I drive away relieved that he didn't get the infection at home. It's not my fault. I collect information in my notebook as if numbers make

sense, even though I see immediately that Chris's blood counts are nowhere near the normal range. White cells alone comprise a complex balance of different cells: neutrophils, bands, eosinophils, basophils, monocytes, lymphocytes, and platelets. It's a wonder anyone maintains normal blood counts. Yet we do, until we don't. Stark evidence of how sick Chris is, not in one place — lungs or colon or brain — but everywhere, every drop of blood out of whack.

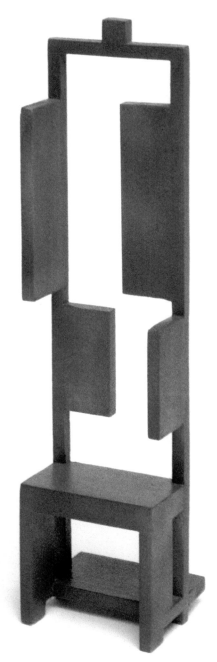

Those who confessed to the practice of witchcraft and allegiance with the devil were jailed but were not in immediate danger of hanging. However, an accused person who refused to confess was very likely hanged. ✦ Secret witchery was clearly more threatening than confession of guilt, and confession was often the result of community pressure. Charges of witchcraft were elaborated and relentlessly seconded by "witnesses" who gave false testimony in the trials. Hearing these claims so often and in so many guises convinced the accused that they were actually guilty. They sometimes capitulated just to end the torrent of verbal persecution.

CONFESSIONAL CHAIR

May 2004

NOSING AROUND THE oncology unit while Chris is napping, I peek at a nurse's clipboard chart, attracted by the heading, "Levels of Consciousness." Who knew that consciousness came in levels? Weren't you either conscious or unconscious, one or the other? I scan the list and once again take notes: "Alert, Lethargic, Obtunded, Stuporous, Semi-comatose, Comatose."

I don't know what obtunded means so I look it up: obtund — *to make blunt or dull; make less acute; deaden.* No wonder I like the onomatopoetic sound of this word.

How is obtunded different from lethargic? Lethargy — *a condition of abnormal drowsiness or torpor; a great lack of energy; sluggishness, dullness, apathy, etc.*

I give up trying to understand how it's possible to know when someone is sliding from obtunded, say, to stuporous. How does one know the right word for a perilous descent?

Why do I persist in writing everything down? Blood numbers. Medications. What this one said, what that one said. Gathering evidence? For what? Who or what is on trial, and why?

May 22

9:00 A.M. — Chris sits in a straight chair near the bathroom door, and I wash his hair, face, back, chest, and arms, moving the soapy cloth slowly from the top down, rinsing it, wringing it out, adjusting the water temperature, careful. Lemon-scented soap and pervasive hospital chemicals in the air mask the smell of his skin, but I recognize it, though it feels cooler, silkier. I wonder how long I will remember that touch and smell. He reaches for the soap to wash his genitals, but feels too weak, too shy, and hands it back to me. Barely touching him, I wipe his flaccid white skin, so vulnerable.

10:15 A.M. — The a-fib (atrial fibrillation), his racing heartbeat, is coming on again. This insane ride: white cells up, neutrophils down. Temperature up, heart rate regular. The cardiologist announces, without irony, "You will have a-fib for the rest of your life and be on the drug Sotalol forever." The nurse tells me his heart rate of 166 was that of a marathon runner.

Chris dozes, exhausted from these episodes, and I go home to walk, shower, and prepare a lunch of egg salad for my eighty-four-year-old mother. I take it to her apartment and make her half a sandwich on white bread. She eats normally and sips the liquid from a cup of Campbell's chicken noodle soup, working her spoon around each chunk of chicken, leaving it in the bottom of the cup. I give Tuffie, my mother's wretched cat, his antibiotic. In her dementia everything about Tuffie torments her: he's biting himself, he's losing his teeth, he's hungry, on and on. Reassuring her that he's fine, I scoop up the five smelly half-empty cans of Friskies littering the kitchen floor and dump them outside in the trash. After lunch I continue on to the hospital.

A nurse tells us the story of her father's sudden death of a massive heart attack and her hateful mother who wants only her brother to visit. "My brother and I wish our mother had died first." Shocked by her bald statement, I manage only a weak "Oh." But her confession about loving one parent more than the other sticks

in my mind. Is it true for every child? Do our sons love Chris more than me? Of course they do. I do! I confess I loved my gentle mother more than my difficult father.

Need: Three books about leukemia ordered from Amazon; one online Medifocus article printed out; white socks, big ones; Scrabble game.

May 23

As I HEAD TO THE HOSPITAL early to catch the doctors' rounds, the vet's office calls to say my mother asked them to pick up Tuffie. What is going on with her and that cat? Does she want to get rid of him? I stop at her apartment. She is lying on her bed fully dressed. Tuffie is sleeping in his chair. I call the vet's office and make an appointment for 2:00. Mom is relieved.

I pause at the door and tell her, "Act as if . . . "

She looks at me blankly. "Yes," she repeats, "act as if." As if you understand something, wretched daughter mutters, stomping out to my car. I escape to the Farmington River Trail instead of the hospital. Picking up my pace with each breath releases sadness that my mother can't help me now when I am so alone. I pause where the river rages over the dam. Why is it so hard to admit I need her, or anyone? Am I too stubborn or afraid, too bound to the idea that need is a sign of weakness? Always acting as if . . . I am just fine.

And all the while I punish myself for not being a good enough wife. A lifetime of putting myself, and us, on trial, I confess it. I loved Chris, and I had complaints I rarely expressed. Does he know? Does he even think about such things? Rather than talk about feelings, he reads, and hands me something to read. He pours emotion and intellect into drawings, woodcuts, and paintings. Passion in ideas.

I do the math: 14,424 mornings his eyes poured into mine, sun through my window, warming me awake. But these past seven

years? Certainly, impotence as a result of prostate cancer seven years ago has affected our marriage. And now monosomy 7, his genetic abnormality. Sevens. We bear anguish alone, yet truth thunders in our eyes, in the marital gaze.

[1964]

A DARK-HAIRED, FULL-BEARDED GUY squashed in the far corner of the long table in the teachers' lunchroom at Suffield High, looming over his tray, glanced up as I entered with a college friend, Bunny, after my interview with the principal. She introduced me to Chris Horton, director of art for the school system. We made eye contact down the length of the crowded table. I asked her about him later. Is he single? Dating? Have you dated him? Yes, no, no, her replies.

That was it until the first day of school after Labor Day, when, wobbly with terror at facing, for the first time, 120 adolescents allergic to English teachers, I saw Chris Horton in the parking lot. Saw him slam the back gate of his boat-like '50s Country Squire wagon and lumber, solid, certain, lugging large newsprint pads and a tattered cloth bag across the pavement toward the art room. I watched until the door closed behind him and wondered where I could sign up for that kind of self assurance.

As the long, long weeks of English-teacher initiation unrolled, I rarely saw him during the day, my classroom in a distant wing of the sprawling one-story brick building. I saw him occasionally at the bar-restaurant where single teachers hung out on Fridays, but usually I was lead-footing my beloved '64 Bug, Blueberry, east on the Mass. Pike to spend the weekend with my college boyfriend near Boston.

I struggled through October, November, December, exhausted from getting up at dawn and teaching five classes, in tears by 4:00 most afternoons with still so many homework assignments to grade and classes to prepare. Bunny, with a year of teaching behind her, talked me through it, nourished me with

scrambled eggs and tuna casseroles, and I survived to spend the holidays with my family.

After Christmas break, Chris Horton described having enjoyed bourbon old-fashioneds and old-fashioned holiday festivities with his family in New Jersey as a new year turned, as he turned twenty-eight amidst considerable hoopla surrounding his younger brother Tim's plans for a wedding in May. I imagined their mother sending Chris meaningful glances regarding his status as not only unmarried, but unattached. With that much pressure, he made a New Year's resolution to court the slender, blond English teacher, and devoted relentless creative energy to that ambition.

Soon after classes began his campaign to win my hand swung into high gear. He asked me out, I was flattered, and soon discarded the boyfriend in Boston. Expressions of desire — pure lust, I would tease — in notes and watercolors appeared daily in my mailbox in the central office, the school secretaries entertained by the antics of one of their favorite teachers in love. Feeling their eyes on me, I ducked around the door into the hallway draining of students and read while dashing to my homeroom after the bell rang. Late again.

> *To my dearest animal, my dearest mind, my dearest soul, my dearest dearest Sherry, you have first and only encompassed me. Everything I have, have done, will do is secondary to the presence of you. I feel stumbling dumb and blind — your reality — it has cut all my artifice from me, my "independence," my self-sustaining deception, my self. I have never felt so entirely a part of some other, some wonderfully beautiful dear, dear person, you, my love. And with all my newly discovered heart, Sherry, I am yours.*

I was stunned, overwhelmed that such a man had fallen so hard for me — ME — his passion more intense than any expression of love I had ever heard, or read. Apparently I had bewitched him. It was operatic. Though skeptical that anyone could see me as "a dear, dear person," I was seduced by his wanting, in thrall to his

constant attention. Why on earth was this kind, intelligent guy with a perfect, tall, athletic body, an artist no less, so taken with me?

I began adapting to his routines at the duplex in the next town where he lived alone: scotch before a dinner of saucy noodles from a box and evenings in his basement art studio where I sat cross-legged on the orange Indian-print bedspread red-penciling homework papers and worrying about how to handle a couple of hulking, disruptive freshmen who never did their work. Chris drank beer and painted. There was always a wildly colorful abstract-expressionist landscape in progress. We showered together in the large concrete stall in the basement bathroom. Warm, wet seduction. Sometime after midnight I dragged myself out of his bed and drove the ten miles to my apartment in order to wake up in my own bed and drive to school with Bunny, as usual, an exhausting effort to keep up appearances.

Another morning, at my mailbox in the front office, I unrolled a large watercolor, "The Graugh of Cranbaughstrau wills you its only child for all time." The Graugh is an egg-shaped abdomen with curving phallic protuberances that balances on one scrawny, many-clawed chicken leg. A gold circle like a wedding-band piercing dangles at the end of a hairy penis. A timepiece with scrambled numbers like a Dali image hangs from its crotch. The Graugh has zapped open an egg and a tiny Chris, Baby Graugh, peers through the cracks, sexuality reborn. The painting is devilish, hilarious, and I laughed out loud, the secretaries smiling, curious at my delight.

I LOVED CHRIS'S LAUGH, the warm smile in his brown eyes. After school I flew into muscular arms that were gentle, never tense or stiff. I felt safe. Why did he want to hold my bony body? How were we a match? I wasn't sure at the beginning, though we had teaching in common, and the arts, and held similar opinions on most of the other big questions. We were never flaky hippies, never did drugs, though it was the sixties and Chris was an artist. We drank scotch and beer, along with everyone we knew, except

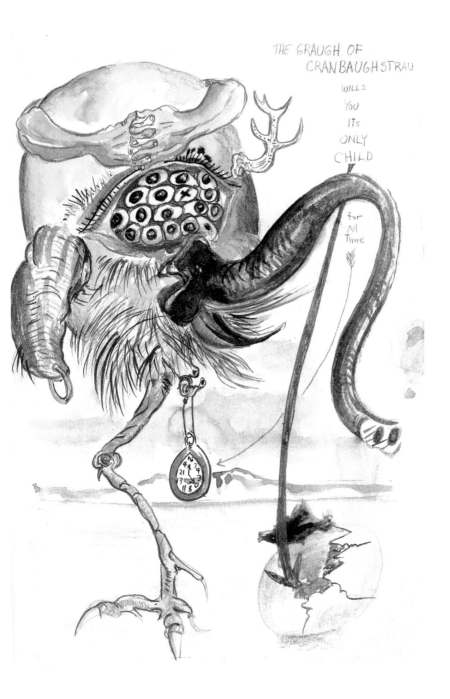

my teetotaling family, of course. It didn't occur to us to drop out, to rebel as so many others were doing then. We had a few radical ideas about education and politics, but our beliefs about responsibilities of family and daily life were much like our parents' and their parents' before them. We were dutiful, hard-working teachers with well-built superegos.

Yet there was nothing conventional about this man's creativity. He labored for weeks to carve my engagement ring from a chunk of ebony, whittling with large, careful fingers until the effort cracked as he thinned it to fit my hand. Soon I began wearing an inexpensive vintage ring with minuscule opals and diamonds we had chosen at an antiques show. Passing me in the hall, students quickly caught on, looking up at me with shy grins.

There I was, struggling to mold myself into a respected authority figure in front of so many teenagers just a few years younger than I, suddenly reduced to a blushing girlfriend. Chris's overwhelming attention competed with the challenge of facing five large classes every day. Afraid of embarrassment, being revealed as a fraud, a failure as a teacher, I relegated my engagement to this determined, larger-than-life man to an extracurricular activity.

One morning a cartoon sketch of himself appeared in my mailbox, his severed neck dripping blood, and one chilling sentence: "If you ever run away I'll slit my throat. C" The image seemed hyperbolic, but still I was shocked—he wouldn't really, would he?—and while it sounded like a threat, all I managed to do was blush nervously.

And he, too, worried. "Though I have been as natural as ever and more myself with you than I ever thought was possible for me, our early commitment has presented the fear of doing something wrong. Thus I may not be really, really me. No, that is not right. It is just that I may be overcompensating (though I don't think so). I'll try to be as real as possible with the wide range of my moods always expressed. Though now my realness is new and different because of you. I will never be the same; you will never really know what I was like. I love you Sherry."

Neither could he know what I was like and would be like. It

didn't seem to matter. Who I was, newly discharged from sixteen years on the receiving end of educational institutions, I didn't know either. This man, who had already succeeded in my chosen profession, wanted me, plain and simple. And, of course, being wanted was most seductive, a compelling escape from the effort to be independent. Chris scooped me up, thrust me into a serious, committed relationship I was not ready for, but sensed was a chance for a new life, a new identity, a promise of stability, security, and everlasting love. I certainly went for it. No time to reflect, time just to react — say yes.

May 25

I'M BACK IN the hospital room just minutes before the doctor comes in to tell us Chris's blood counts continue to improve. He will have another BMT (bone marrow test) tomorrow and then go home to await the verdict. "You have done very well given the assault on your body. I am cautiously optimistic about remission. If you aren't in remission, Sloan-Kettering will explore salvage treatment." I cringe at the word salvage and at doctors' double-edged statements. We get out the cancer notebook and write questions: What does salvage treatment mean? Do his cytogenetics (abnormal chromosomes) make further treatment unwise because it won't work and isn't worth the discomfort? Will we raise these questions with doctors?

Josh visits for a couple of hours. Chris says later, "He was cracking jokes like crazy, making me laugh."

The next long, quiet day, we listen to Bartok on WFCR and read *The Times*. I call my mother, "Chris will be going home tomorrow."

"I'm weak," she says. She can no longer process what I say. I swallow, though I want to bark at her.

"Eat something."

"I'm having cottage cheese and toast."

"I bought some ham. Roll up a slice and dunk it in the cheese."

"I will." But does she?

After three hours, I'm antsy and leave with a load of stuff—Scrabble board, greeting cards, CDs, slippers—as much as I can heft in a large garbage bag. It's bulky and heavy. I struggle. At home several friends call with advice about the best hospitals and doctors. Over and over I say, like an automaton, "That's a good idea, thanks," reminding myself that it's Chris's decision. But how are we supposed to know what to do? I do nothing this long Memorial Day weekend but watch Chris for signs of infection.

Monday, I scurry around making carrot soup and Chris cuts up greens, turkey, and cheese for a salad, which his neutropenic diet prohibits, one eye on chopping and one out the window overseeing Toby and Lori, who are toiling a second full day in the backyard. They shape prickly yews under the kitchen windows that we haven't touched in twenty years. They cut back the Andromeda and a tenacious, delicate pink flower, Artemisia, I think, that crawled through the low brick wall into the sunken garden. Then they tackle the Connecticut Willow Project, as Toby calls it, a dozen willow stems he brought from Cazenovia, New York, where in grad school he is reclaiming a willow park to purify storm water runoff. We watch him thrust the straight six-foot rods where the soil will receive them. "When they are happy, they double their height in just one year," he says. "If they are happy here, I will weave them into a living fence."

"The Native Americans once wove them into baskets," Chris adds, his research for the Salem chairs project fresh in his mind, giving him renewed appreciation for a culture destroyed long ago. He tells Toby and Lori he appreciates their hard work, though later grumbles to me about his son's fearless, somewhat impulsive, whacking in the yard, "taking over" what has been his territory all these years.

Early the next morning, Chris's father, who died three years ago, appears in a dream. He fades into the distance and I don't know where he goes. The dream is full of regret for lost opportunities to communicate with my dear father-in-law, whom I knew from the beginning was the sensitive, spiritual father I

needed. Later, I became more aware that he was often withdrawn, distant, like his son, or maybe it was only his deafness. Still, the Horton home was warm, orderly, a place where I felt secure, the kind of home I wanted. The kind of home where touchy subjects were suppressed, not only by the parents' Yankee stoicism and traditional gender roles, but by bourbon or gin, though I didn't see that then.

As in so many homes in post-war middle America, ballooning in the newly domestic 1950s and continuing well into the '70s, the cocktail hour was sacrosanct in the Horton household I married into in 1965, a daily togetherness I had never experienced growing up in an anxious, disconnected family. Chris's father tended bar at the kitchen table, though he drank only tonic water with lime, and served drinks, gin and tonics in summer, bourbon old-fashioneds during winter holidays, on a lovely hand-stenciled tray. He lowered it carefully to the marble coffee table in front of his wife, who had already arranged two or three kinds of delicious, fussy hors d'oeuvres within reach of her grateful husband and children.

The cocktail hour — it should be in caps, the COCKTAIL HOUR — was a time to gather in an elegant living room, in winter before a welcoming fire, to wind down the day, to talk quietly, to chuckle at witty remarks, sometimes to snuff out an argument that might threaten to flame between Chris's brother Tim and me, usually about women's "libbers." No one had more than two drinks. Promptly at 6:30, as Dad Horton expected, the gathering moved to the dining room table, where the "girls," Tim's wife Madge and I, served dinner, which Mother Horton had prepared as she ate her lunch, potatoes and carrots sitting in water all afternoon waiting to boil or a cheesy casserole made with Campbell's tomato or mushroom soup. After dinner the "girls" were on dish detail.

AT THE CLINIC the next day the doctor says, "Your bone marrow is rebooting. It's a little stunned and may take a while to behave normally." While it must be good news, instead of hearing this as a

positive sign and growing more alert, listening and talking, I grow more numb. Stuporous or merely lethargic. Where am I on the "levels of consciousness?"

Looking at Chris across the dinner table, I see that his eyes are as dark and intense as his mood, like mine. He stares at me, "The books say AML comes back quickly and strongly." He feels doomed. I don't interrogate what he has read, or him. I don't want to hear him confess that he is ready to give up. I don't ask, do you want to let it happen, forgo treatment? Like Dr. Nuland, who describes with great poignancy his experiences treating terminal patients, in hindsight, if I could have been less emotional, Chris and I might have had a conversation about his prognosis and treatment. We would have needed help with that discussion from an empathic professional who sat with us and encouraged us to air our questions and fears, who wouldn't let us get away with avoidance, and who helped us identify all the ways to handle that incredible experience. Such a discussion would never happen.

Instead, I write: "The wind and the rain came and I stepped into it, thankful, thrilling in the cool wet time of your illness, a high river bank between us, and between us and all the rest."

█ █ █

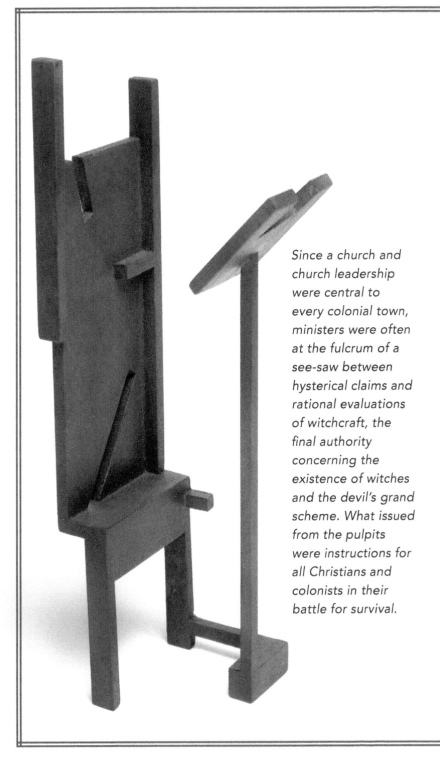

Since a church and church leadership were central to every colonial town, ministers were often at the fulcrum of a see-saw between hysterical claims and rational evaluations of witchcraft, the final authority concerning the existence of witches and the devil's grand scheme. What issued from the pulpits were instructions for all Christians and colonists in their battle for survival.

Pulpit Chair

June 2004

PRESIDENT REAGAN IS dead. It's all that's on TV this week. Glued to the screen, I follow every motion of Nancy Reagan's hands. Hands tell on us, tell everything. Chris's dexterous hands, his graceful, long fingers, are quieter now that he no longer smokes. For thirty-seven years, from Army basic training on, every fifteen minutes or so he felt the bulge in his shirt pocket with his right hand for a pack of Pall Malls, tapped the bottom to draw out a cigarette, brought it between his lips, flicked a small, green plastic lighter, cupped both palms around it and inhaled deeply, cradling the cigarette between his right index and middle fingers. To hold the warm, enveloping hand available to me, I had to be on his left side.

Our house smelled of stale smoke, filthy ashtrays in every room, gray-brown dust cloths and sponges when I cleaned. Well, and the smell of cats, we always had two cats. Smoking seemed harmless in the beginning. Sophisticated. When the Hortons gathered for holidays in New Jersey, I sat at the kitchen table every afternoon with my new mother-in-law and Madge, sipping dry sherry and smoking Kents. Madge said later they had referred to me as "the baby." They smoked, I coughed and

gasped to catch my breath in a pathetic attempt to fit in. I was better at drinking.

AT BREAKFAST, a fidgety Chris complains about the way the grape vines outside the kitchen window angle from their roots to the cross support that Toby built. "They should go along the ground and then up the vertical post," he asserts. These vines, once vigorous with large, dark leaves and ample fruit, have faltered from tangling with a barberry bush. I don't know if they will survive, perhaps with a shot of fertilizer. "I'll fix it," I say.

We head to Manhattan's East Side for an appointment at Memorial Sloan-Kettering, the first of three meetings with medical experts to seek treatment, hopefully a bone marrow transplant. We check into a hotel and then explore the East River neighborhood. Chris carefully maneuvers the canine traffic, revealing significant anxiety only in snapping at me, which he does more now than ever before in our forty years together. It surprises me. It feels as if he's pushing me away, but fear has to spill over somewhere and I'm here.

At 6:30 the next morning, I jump out of bed to the beeping alarm and wake-up call and throw open the dark, heavy drapes to a cloudy view of the East River. I slept fitfully. On TV endless shots from high in the Capitol Rotunda spotlight Reagan's flag-draped casket. Next to the TV is a complementary liter of Pellegrino water we can't open.

It's a short walk to Sloan-Kettering at 66th. We meet Tim, who has driven into the city to be with us, and we sit a long time in the chilly waiting room, a maze of plastic seats linked together. Some people stare at rolling scenes of Reagan's funeral on the television mounted near the ceiling in one corner. Others flip through magazines. I pace around to warm up and calm down. Chris and Tim, clearly brothers, "Big Honk" and "Little Honk" their Amherst College nicknames, sit side by side saying nothing.

Finally, a stocky, middle-aged doctor in black-rimmed glasses and startling white coat, his thatch of straight, wiry, salt-and-

pepper hair needing a trim, ushers us into a small office and closes the door. After quick handshakes, he gestures toward three chairs in a semi-circle and takes his position behind the massive wooden desk between us. In a quiet, ministerial tone he launches into a summary of Chris's current status. "A probable diagnosis of MDS, myelodysplastic syndrome, means your immune system is compromised, your prognosis poor. The missing chromosome 7 means it's harder to get into remission." My mind shoots the moon. MDS? What is that? It's the first we've heard of it. And where did chromosome 7 go?

We don't dare interrupt him to ask how Chris got MDS and when and why. We are intent on his words. "One of the kinds of bone marrow transplants, allogeneic, would kill you," he pauses, "at your age." He tilts his head toward the cluttered desktop and we follow his gaze. I note the chaos of busyness. He continues, "The challenge is modulating the battle that occurs when your immune system rises up against the transplanted cells. This is called graft versus host disease (GvHD)." The body's immune system interprets the alien cells as an invasion. A chemical battle ensues; good or evil wins. Doctors try to control that battle. They will lose it.

He concludes, "We don't have any trials for you here. Complete remission is necessary in order to proceed with any kind of transplant." Chris thanks him with a handshake, and the three of us file out of the world-renowned cathedral, Memorial Sloan-Kettering, silent, subdued.

On the way home Chris scribbles questions. Can a sixty-seven year old stand such high doses of chemotherapy? He worries about cerebellum toxicity. He worries about the effects on his heart. Perhaps there are other chemo trials with new drugs available. Or is he just too old? I worry that we should be conferring with others somewhere — Seattle, Houston, Baltimore — to get second and third opinions, but Chris shows no interest in traveling to clinics beyond a convenient driving distance from home. I don't push him.

He pores over stacks of paper on the dining room table. He calls United Healthcare about coverage of a transplant and learns

he has indemnity coverage that pays eighty percent of what Medicare doesn't. So instead of a new car, we will buy a state-of-the-art, peripheral-blood stem cell transplant — a PBSCT! If one is available to us, that is.

Later, sitting in the den with the newspaper, Chris looks up briefly to complain he hasn't felt as well today. I glance at him with a sympathetic nod, and we lower our heads to the paper, pretending to read about priestly sex abuse scandals. My thoughts whirl me far from this evening in this comfortable room. Perhaps prostate cancer gradually wrecked his immune system; perhaps the psoriasis, or whatever it was, vascopathis, two years ago was a symptom of MDS, which evolved into leukemia. Lost in fear, what can I do? Talk more, obviously. But instead of exchanging thoughts, especially fears, we choose to protect the other, and of course the self, by maintaining our normally quiet relationship. Is it false? Maybe, but it seems necessary in order to go on, to care about any of it. Familiar, it's our modus operandi.

June 18

CHRIS WRITES AN EMAIL to our distribution list: "I am sorry I can't thank each one of you with 'face time,' as the corporate world calls human contact. My present condition is strong and healthy (except for some A-fib), almost thirty pounds lighter and almost hairless about the head. The transplant process will probably be sometime in late July or August, squashing our annual Maine sojourn. Sherry has been absolutely wonderful, supportive, calming, disciplined (and disciplinary when necessary). Everyone should have the opportunity for a formal wedding ceremony — 'in sickness and in health' — such important words."

Two days later, Sally, my college roommate for four years, calls with birthday greetings. Our conversation settles on this day, forty years ago, when I was her maid of honor. She says I wore deep blue *peau de soie*, and I had made the dress myself. I don't

remember any of this. I see myself on June 20, 1964, sitting alone in a rear pew of the small Methodist Church in the northern Maine village where she grew up, watching the ceremony from a distance, tearful.

The forgotten self had apparently been a good friend, planned a surprise bridal shower instead of studying for comprehensive exams, fashioned small tulle hats for the bridesmaids, and stood with the bride during the wedding ceremony. The remembered self was estranged, alone without my boyfriend, missing him, perhaps jealous of Sally's marriage, wanting, wanting; perhaps afraid of stepping out into life alone; and yes, critical of her decision to be married before having a time of independence. I imagined her, such a bright woman, a math major, stuck on a Navy base making curtains and dinner, waiting each day for her husband to come home. That young woman, the maid of honor that day, said "I do" one year later.

[1965]

CHRIS AND I MET and married. Or it seemed that fast: five months from our first date in January to our wedding in June. I was afraid to wait until fall and spend the summer apart, later wondering what kind of love would not have survived a two-month separation while Chris taught painting at the Cummington School of the Arts.

Yet, while he urged me to spend the summer there with him and marry later, I could not "live in sin," even though we were engaged. No, my mother and grandmother would be horrified. I had managed not to horrify them, not to "go all the way" in high school because Mother believed that if I did, I would, you know — the key word never passing her lips — and if that happened it would kill my grandmother. Mother asked her friend Rita to inform me of this. I could only conclude that someone close was bound to die if I did something I really wanted to do.

Mother left it to the minister's wife to whisk me away to a

weekend conference with a small group of pubescent girls, who, already confused about such matters, sorely needed instruction in the correct facts and proper behavior concerning the physiological changes assaulting us. And most important, how to handle such turbulent feelings around members of the opposite sex. We were given a paperback to study.

I saw a movie full of the steamy sexual energy that consumed me: Connie Stevens and Troy Donahue in *Parrish*, filmed in a nearby town. Every Friday or Saturday night date—ten-pin bowling, a stock car race, or hockey game—concluded with my boyfriend parking his vintage '40s Ford coupe on a dirt road behind a tobacco barn to engage in heavy petting: going only so far, hitting a double, not a triple, and certainly no home runs for that girl and boy.

I saw the play *Blue Denim* with Carol Lynley, whom I resembled slightly. That play unleashed the nightmare of unwanted pregnancy, the specter of a ruined life should I succumb to intense desire, should I let the devil in to ruin not only my future but my whole family. Indelible cautionary tales. Taught to please, I absorbed those good-girl lessons, the pulpit delivering the same message as my puritanical family.

Fortunately, though, before adolescence confused and tortured me, many girl-selves competed for dominance. At ten, eleven, and twelve years old, I was a "professional" farmhand during summer vacations on my great uncles' farms in northern Vermont. I marched heifers to and from pastures, commanded workhorses—Ned and June—to pull the manure spreader, and slopped hogs in the muck under the horse barn. No one needed to say it was important work, that I was doing it well. I knew it and blossomed from those months in the country, twelve hours a day outdoors reveling in smells, sunburns, and sore muscles.

Another girl wanted to be different, daring, even wild, unconcerned with what others might think. I imagined myself Amelia Earhart soaring around the world and Nancy Drew solving mysteries, and other active heroines of book series I devoured. And then the sweet one, enamored of beautiful actresses,

studied two-dimensional versions of Doris Day, June Allyson, and Grace Kelly in paper-doll books. I cut out all the pieces of their wardrobes, dressed and undressed them, bending tabs carefully over their shoulders and around their waists.

So I withheld, became a master at withholding, until Chris Horton, an older man — well, only six years older but so much more sophisticated and brilliant and creative than my other boyfriends, and over six feet tall and athletic — unlocked the gate in February, seconds after proposing marriage. Since I was engaged, Mother could whisk me off to her physician, who put me "on the pill." The Brand New Pill.

I just wanted Chris to tuck me into his life, give me his Horton name, and I would adapt. He would be in charge of happiness. My mother was happy to plan an affordable wedding, and Bunny was happy to be my maid of honor. Two other college friends and my sixteen-year-old sister were bridesmaids. At the bridal shower, I exclaimed over the Sunbeam electric hand mixer, silencing the me who disdained most things domestic. I would bury contradictory feelings in my bouquet and, head high, smile through it all, proud at last, my life transformed.

We did not get married in the Cummington hay field as we had discussed: what if — laughing — oh, but we can't really do that, can we? The two o'clock ceremony was held in the rural Congregational Church a mile or so from my parents' home, where I had bowed my head to the figure in the pulpit until I went to college to bow my head to professors. On the day of our wedding, a year after graduating from college, that pulpit was empty to me. Learning about world religions had purged me of any specific one. I no longer went to church. I did not know the minister who married us. I was going through the motions.

But just think of the education I had absorbed in Congregationalism, the church of the Puritans; Chris, too, in a Lutheran church. All those K-12 hours and years: do unto others, turn the other cheek, love thy neighbor as thyself, and countless thou shalt nots; singing in my alto voice all the prayers, hymns, and anthems, harmonies so comforting. In the choir loft, I could

touch the pipe organ if I reached for it. That place was my salvation, Sunday morning atonement for guilty Saturday nights.

On a perfect Saturday afternoon, June 26, 1965, I said "I do" with such emphasis I surprised myself and all seventy witnesses, leaving no doubt in my own or anyone's mind that with this man I would have a perfect life. We bowed to some conventions—white gown and black tux, church ceremony—but not others. There was no traditional wedding march, no statements vowing obedience, no wedding photographer or wedding album.

The reception in a drab Knights of Columbus hall was a punch-and-cookies delight to please my teetotaling family. After the requisite two hours of smiling and murmuring thank you, I changed into a fitted linen suit in a flower-garden print, off-white gloves and matching pillbox with a splash of netting, and we escaped in Chris's old wagon, crepe-papered and shaving-creamed with "Just Married," Esmerelda and Golum meowing, the back end sighing with the weight. We climbed secondary roads to Granby, Connecticut, on to Granville, Massachusetts, skirted Westfield, turned right in Huntington onto route 112, to Worthington, and finally to Cummington. Chris knew the way. I had never been on this route. The radiator overheated just once.

He turned onto Potash Hill Road where a small, hand-painted sign indicated Cummington School of the Arts, and filled me in on some history. Katharine Frazier, harpist and professor of piano at Smith College, bought the property in 1920 as a summer retreat where she and select students could practice and take lessons. In 1930 it became Cummington School of the Arts, governed by Frazier's incarnation of John Dewey's progressive education theories. She died in the white Federal Colonial in 1944, where her spirit, Chris said, still occasionally wandered. The name, CSA, stuck, and the school prospered until the mid sixties. Our honeymoon summer, 1965, was the school's last.

We rolled downhill past the small early cemetery and turned into the next lane leading to a beautiful stone house. Chris talked on and on, mapping the land, pointing out the one-story barn-studio where he taught art classes. A hayfield sloped downhill.

He backed the overloaded car down slowly, sucked in his breath as the muffler dragged on lumpy mounds, to the path that led to a rustic, fieldstone sculpture studio, where other summers he had entertained other women just beyond woods' edge. He confessed to one nimble circus acrobat who, I assumed, in order to have been a student there must also have practiced a more traditional art form. Though he presented her at the end of the summer with a thank-you gift of his grandmother's ruby ring, when she met his parents in New Jersey — as the story went — she failed the Mother Horton test. His engagement to the acrobat was brief, the ruby returned.

Our "bridal suite" was one large room, both art studio and bedroom. We spent our first week of marital bliss in bed, oh yes, but very sick with dysentery, negotiating the primitive bathroom our first relationship challenge. No one came near us. In the woods with no phone, no link to anyone I knew, so very sick, what a honeymoon! Eventually the directors of the School decided our wasting condition was serious, tested the water, and discovered that a dead animal had contaminated the well. Once drinking water was delivered from the School's kitchen, we slowly recovered.

It took more time to adjust to life at a school for artists where I was the art teacher's appendage, not there on my own merit, a distinction I felt keenly. While living his life was what I had yearned for, since I wasn't an artist I was convinced I didn't belong.

That is, until I met the resident poet and sat in on his writing class. He asked everyone to write a short poem, in any form, on any subject. He was witty, very welcoming, and I thought I'd try it. I sat staring at Chris's small painting of two dead crows against snow, beside a red apple with a big bite taken out of it, and eventually described the scene, why and how, I don't know. Terrified of ridicule, I took it to class and was shocked when the poet declared it good. Of course he was being kind, and I didn't dare believe him, but still I couldn't have been more thrilled. I began keeping a journal of observations and ideas. I would scribble more "poems" over the years, but only sporadically, lacking both the discipline and the confidence to practice the craft.

June 25

CHRIS AND I again go shopping for an authority figure to believe in, this time at Dana-Farber in Boston. The young hematology oncologist, tall and lanky, with crisp, black hair and a narrow, pale face, pointy chin, twitchy in his rolling computer chair, reinforces what the doctor at Sloan-Kettering told us about MDS. "You have had leukemia brewing for some time." I catch my breath, how long is "some time"? How can our own body betray us so, we ignorant of its schemes.

"In your case," he asserts, "the cause is probably smoking." No one else has said this. He continues, "MDS is not necessarily treatable. The only effective therapy is a marrow transplant. Because monosomy-7 suggests MDS, you have a very adverse prognosis, the worst one."

Hope: treat with a marrow transplant.

No hope: you have the worst possible prognosis.

The hematology expert swivels in his black leather chair as he proclaims medical facts to attentive supplicants whose blank faces nod slightly. His eyes darting from screen to fingers flying on the keyboard, he goes online to the National Blood Match. He pumps us up.

"You have seventy-one matches. I want to find a young, healthy male, and with that many matches we'll find someone. We will start searching immediately for a donor, which will take a while, two weeks to six months."

Hope. We leave Dana-Farber, believers. We will follow their strategies and instructions. No matter how dire our situation, we will be saved.

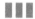

Survival in Salem and surrounding communities depended on successfully building homes, clearing land, harvesting crops, nursing the ill, and caring for children, as well as the good will of neighbors. Naturally, neighborly relations were not always amicable or productive. Human nature ensured that jealousy and spite appeared from time to time. These negative qualities, fanned by rumor, sometimes exploded into accusations of practicing witchcraft, thus destroying previously strong social bonds. Many neighbors signed petitions supporting the innocence of the accused, but many others turned against them in fear and hatred, blaming all their own problems on the supposed witches.

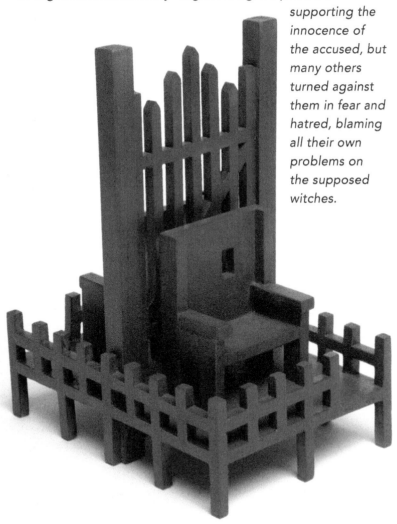

Neighbors (Gossip / Rumor) Chair

July 2004

T HIS IS IT. No remission, no transplant, even if a donor is found. It would be counterproductive to introduce healthy donor cells into a diseased blood stream. How long will we be in the hospital this time? When did I adopt the plural we?

Once again, I push the button on the wall outside sixth floor oncology, activating thick metal doors that part like the entrance to an alien world aglow with artificial sunlight. Science fiction. My nose crinkles against odors that layers of disinfectant fail to mask. I nod to familiar faces at the nurses' station. I wonder what they say about me or if their eyes even focus on the woman walking by. I may be invisible.

Waiting for Chris to be brought up after having a new intravenous catheter implanted, I settle into another vinyl recliner in another sterile room, feeling more subdued than in April and May, when we had no idea what would happen or whether he could tolerate the powerful treatment. He did. Vital organs absorbed two chemo assaults and would now endure a third.

I make another list: Order Biotene products for mouth care. Buy soft toothbrushes. Bring in Scrabble and the Salem drafts.

Later in the afternoon, IV lines snaking across his chest, Chris

leans against three pillows, white sheet pulled up, PC on his lap. He's designing another chair about the loss of trust among friends and neighbors when paranoia consumed them during the witchcraft crisis. This chair has neighbors sitting back to back behind an imposing fence, not facing each other, with only a small hole for whispering the news, truth, or lies, who knew. Like the gossip we repeated in school, the rumors we passed on or were told about us, this chair represents the challenge of anchoring a truth about anything, historical or personal, about our friends and family, our colleagues, ourselves.

A doctor enters. "With the consolidation therapy you're about to receive, remission can last a year or leukemia can come back fast." We hear only "one more year," not that cancer could win. We don't discuss it.

We go on, "for better or for worse," just as we always have, and I think about all the conversations we have not had. The only time I remember confronting Chris was during the traumatic summer of 1971. I didn't know he ever thought about that time until he said recently, "I put you through hell," his body tethered by IVs releasing the unconscious. Shocked after thirty years of silence, because he said nothing further, and because it did not sound like an apology, though perhaps he meant it to be, I said nothing further. Why dredge up the past when we need all of our strength for what we are facing now, I reasoned. Avoidance my specialty.

But memory burns like a painful splinter that burrows deeper into compliant tissue when you dig at it.

[June 1971]
Cummington Community of the Arts

I STRUGGLED UP the steep front staircase of Frazier House to our two small bedrooms and connecting bathroom with load after load of baby equipment, weighed down with a full-term fetus. Chris and two-year-old Joshua were off somewhere in the two hundred

acres of fields and woods helping community members — some returning for a second or third summer, some new — move into the outbuildings that had been transformed into living spaces. Singles lived "down the hill" in the dorm-like barn. "Up the hill" families in separate dwellings had more space and privacy.

The up-the-hill-down-the-hill dichotomy had first emerged two years earlier, in 1969, in the debate over whether parents of young children would go to Woodstock, and to some extent the schism continued each summer. One parent putting children to bed freed the other to roam, attend concerts and discussions, develop relationships with members. Rumors flew about who was sleeping with whom, who took what drugs, whose marriage was on the rocks. How much were Chris and I, as directors, responsible for those late-night shenanigans? I was a full-time mother of a toddler and nine months pregnant, exploding . . . when, when will this baby come? While I put Josh to bed and stayed with him in the evenings, Chris wandered up and down the hill talking art and philosophy, listening to and drinking with the younger artists.

During the day when we joined everyone for meals in the central dining room, I watched him flirt with a college student, ignoring me and my mountainous body. Who could miss the magnetism between them, the adolescent blushing. Ashamed, furious, whatever I said took on a bitter tone. Yet, instead of accuser facing accused, pointing a finger, having it out, I focused only on having another baby, the pain of birth and the death of love commingling as we drove to Hartford to deliver our perfect second son, Tobiah. And still, sleeping between breast-feedings, devouring delicious food Chris's mother prepared and served — she had swooped in from New Jersey to help — I expected him to take care of Josh, foolish enough to assume the unvoiced tension between us would simply dissipate.

In a few days we returned to our rooms in Frazier House and to our Cummington duties. One evening after dinner I sent Chris off to a dance down the hill because he was the director and everyone wanted to see him. I put Josh to bed and, a couple of hours later, after nursing Toby asleep and checking on Josh,

I drove the few hundred yards to see for myself the dance in full swing. I stood outside in the dark and peered through an open window at everyone swaying to Rod Stewart's *Maggie*. I didn't see Chris at first, and then I did see him toward the back of the room dancing with her, laughing, looking so happy. Sick, I stumbled to the car and drove back up the hill, threw myself on our bed. Sleepless hours passed. Watching the clock, I paced the wide pine floor of our bedroom, sank into the rocker, and nursed Toby back to sleep, then paced some more, waited, and waited. I knew but I had to be certain. Again I left our babies alone — how could I have — and drove the short distance down the hill. The barn was empty, all the lights off. What time was it, for God's sake? A young guy sat on the steps in the thick, humid dark.

"Did Chris leave?"

"Yeah."

"With Joan?"

"Yeah, a while ago."

Oh . . . my life. Back in our bedroom hurt and pain morphed into fury. Through the early morning hours I slammed the rocking chair back and forth, thrashing someone — who? Who was guilty, who innocent? When Chris finally crept up the steep staircase I flew at him, punching wildly. He grabbed me and tried to hold me, to exorcise the witch attacking him. "I didn't think you'd mind," he insisted, frantic eyes searching mine.

"Mind? Mind!" I refused to meet his terrified gaze. Apparently I had given him permission, and he was innocent. Apparently I should be grateful he was happy.

"It means nothing," he cried over and over, "I love you, I love you! It will end immediately."

"It means something, you asshole," I hissed, vicious, listening for a child's cry, not waking Josh and Toby my main concern even at that moment. In our bed I turned to the wall, curled my body into a tight fist.

For weeks, shamed, distraught, my stomach ached. I couldn't eat, sleep, look at him or anyone except Jackie, my dearest friend, who took Josh outdoors to play. Hidden away indoors I nursed

Toby every few hours, changed diapers, sang and read "Humpty Dumpty" and "Jack and Jill," then fell into bed at night, our bed.

Silent rage consumed me. You will not get away with this. You are not free to leave me with two babies to care for alone, your sons. No one would hear those words, but I wonder how much of my anguish seeped into the core of our tiny boys. I wanted nothing more than to pack them up, sneak out after dark and race to my own four walls in Connecticut. I would escape that perilous place. I wonder what would have happened. Would Chris have followed me home? Would it have meant the end of our marriage?

I listened to others older than I. Jackie sat next to me on the bed and took my hand. "Manny told me to tell you not to run, to stay and face it, put your family back together. I think he's right," she said, putting her arm around me. "The other parents are giving Chris hell." I will never know what they said to him, what he said, what gossip swirled about us.

I listened to my own voice: Don't be selfish. Think of Chris, immersed in the heady, intimate experience of community. More important, think of Josh and Toby. Don't be a martyr, I lectured myself, don't be melodramatic, don't be self-destructive. I don't hate anybody; I'm just sad. He said he loves me. What will happen? What will happen? We seemed, and I certainly felt, alone in the world, cut off from blue sky and distant hills.

On the surface, little changed. What happened to threaten our union had to happen, given that time and that place and the nature of our relationship. Instead of leaving, I nestled into a world of my own making, mothering a toddler and nursing an infant, their every breath all I could see, feel, know. Joshua fussy, inconsolable, climbed into my lap every time I tried to breastfeed Toby. Finally, I sent him to Vermont for a few days with my mother. How could I have? Later, she made sure I knew that he had stared out of their kitchen window and cried for his mommy, and she had cried along with him. Poor little tyke. My mother didn't know the truth, only that I was exhausted—true enough.

Chris and I powered on, doing our duty, finding solace in the necessary details, he within his role as leader of an entire community.

How was everyone doing? Getting along? Satisfied with their CCA experience? Masters of the everyday, we provided for the care and comfort of children and a working artists community: food for three meals a day times forty people; responses to questions, ideas, problems, needs; driving our Country Squire wagon to the laundromat in Northampton and the produce market in Hadley for crates of lettuce, tomatoes, melons, peaches. The garden on our hill was not ready to harvest.

Chris and I lived together, slept together, made love in separate worlds in the same bed, like parallel universes. In parallel-play mode, apparently, I doing my thing, he doing his — why not? Why couldn't I say: go ahead, have fun, break the bonds of "nuclear family"? He assumed I had at least implied as much. In the spirit of the "free love" seventies and the contemporary milieu of "open marriage," I could understand his confusion. Part of Chris surely felt confined by the demands of a young family. Part of me felt the same way. I, too, wanted to be a full member of the community, an artist on equal terms with everyone else, not just the admin-go-to person, not just a sleep-deprived mother reeking of sour milk. Even in my official role as co-director of the community, I felt as isolated with a newborn as I had felt six years earlier in a new-born marriage.

The Cummington philosophy of a utopian community — it would be a perfect "new world" — that had thrilled and seduced us, both of us, had an underside, like undulating goldfinches, undersides of leaves. Young, idealistic, we hadn't seen the storm brewing, playing with us, flirtatious wench teasing, dancing round the hills. Electricity sizzled with egotism, jealousy, rumor, spite, betrayal. Some who dipped into the drugs and sex down the hill brought devastation to their relationships. Some wounded marriages survived and healed. Some did not.

I had to grow up, shed the myth that an ideal someone — my savior, my prince — and a perfect life — white picket fence and a rocking chair on the front porch — would save me, would last forever. That made-in-heaven, Barbara Cartland, Cinderella fairy tale in ashes strewn all over Potash Hill.

Our charade ended as the summer community of 1971 came to a close in late August, when everyone packed up and left to begin the academic year as teachers or students. At the final meeting, no one questioned Chris when he announced that, after next summer, it would be time for others to take a turn at organizing and managing the community. During the coming winter, we would make any changes necessary to ensure the community would be stable, sustainable. We were nothing if not conscientious.

Afraid of our unhappiness, we returned to Lovely Street to resume the clear roles and responsibilities of a marriage more like that of his parents, in which a husband and wife were good to each other and rarely argued. Shame bred silence, both of us from reserved New England stock: You make your bed, you lie in it. No one in our families ever knew how our marriage had been sideswiped. Like my mother, I let resentment fester. It was easier and much more destructive.

Chris and I came to terms with disappointment alone, accepted and stored it in a secure, air-tight container, the marriage vault. Though fear squandered the kind of intimacy that words carry, silencing our deepest truth, it still surfaced. We read it in one another's eyes, in gestures, read it in our touch.

■ ■ ■

A prevailing belief among American colonists at the time was that the devil was implementing his master plan to take over the whole of settled America, destroy the colonies, eliminate its inhabitants, and return the land to his minions, the Native American Indians. Magistrates adhering to this belief likely felt they were the last defenses in a life-and-death battle for colonial survival. Having failed to protect the colonies from attack by the Indians and the French, some magistrates may have projected their own perceived shortcomings onto the notion of witchcraft. ✦ Most magistrates conducting the witchcraft trials were not from Salem, yet they pursued suspected witches through their discovery, prosecution, and execution. They were far more committed to this task than were local citizens, many of whom supported the accused with petitions and lists of signatures attesting to their good character, religious dedication, and innocence.

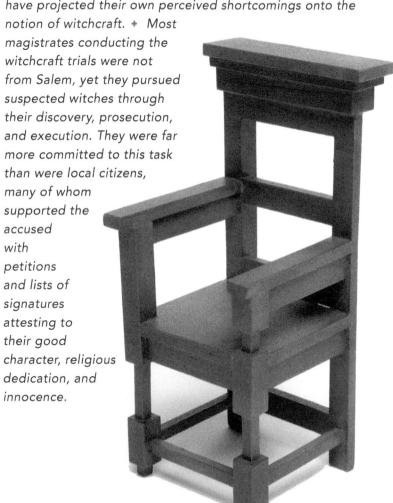

Magistrate's Chair

July 2004

S ITTING AT OUR kitchen table three months into treatment for AML, Chris is writing the text for the magistrate's chair, and we talk about the failure of magistrates to protect the Massachusetts Bay Colony from threats of annihilation during the two Indian wars.

He takes a break to send a long email, which says in part: "The Salem phenomenon and its legacy are still very much with us. . . . Iraq is a morass bloating the news, and few of us know what is really happening to our country — little vision and even less insight into our nature and needs. Why can't we have more leaders who are analytical, thoughtful, and courageous?"

Whenever we hear news about the wars in Iraq and Afghanistan, or wherever the U.S. is exercising its power, Chris researches past events, his intellect chewing on similarities and differences over time. He doesn't let go. Eventually, he makes surprising, meaningful connections that result in a work of art.

Every day we keep our appointments: I give blood at the Red Cross; Chris receives blood at the hospital outpatient clinic. When I return to pick him up, I stare at the man sleeping in a lounge chair next to him. At first I think the man is a woman, but then notice eyebrows that look masculine. Wrapped in a white

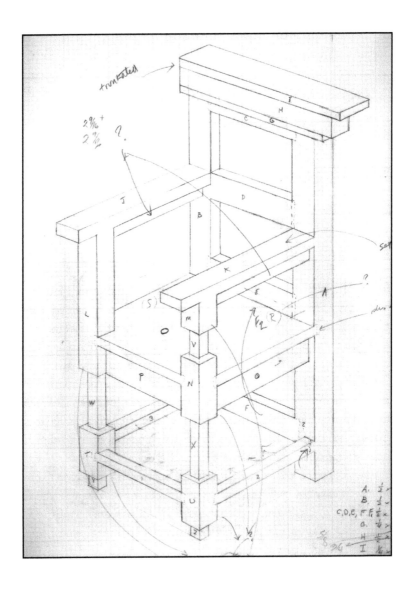

blanket, he is diminutive, curled up with only his small, bald head visible on the white pillow. Chris is disturbed by this. "He was making horrible sounds, I thought he was dying. He didn't know where he was."

That night my mother calls at 1:30 A.M., crying, nauseated. It must be my fault because I made her take the doctor's recommended dose of Tylenol and aspirin. An aide is looking for ginger ale to give her. Groggy, I sit on the edge of our bed and wonder what I should do, go hold her hand at this hour? She should get a grip, her wretched daughter complains to herself.

I visit my tiny, hungry bird-mother. She is sitting on the couch in her robe, holding a Styrofoam cup of ice cream that has been in the freezer for who knows how long. I heat up some Campbell's chicken noodle soup and hand a cup of it to her. She eagerly spoons in the broth and soon announces, "I'll go to the dining room for dinner. You can leave." At home, Chris is a bundle of positive energy. He rides the exercise bike, prepares dinner, sorts his papers. I'm a blob.

Two days later the Gables' nurse calls at 7 A.M. to report my mother's vague symptoms: heart and stomach not feeling right. "I'll be over," I say.

Mom calls back, her voice quivering. "Stay with Chris."

"He's okay. I'll be there soon."

She is sitting up in bed in her soiled, pastel-flowered robe. "My stomach is uncomfortable." I boil an egg and she eats half of it along with soggy bits of toast she has soaked with hot water. I notice she needs a new mat under the dish drainer and a new scrubby sponge for cleaning pots. She walks around, then sits in the living room attempting a simple crossword puzzle. I turn the pages of the *Hartford Courant*; CNN is streaming news of Guantanamo Bay, the prison where accused terrorists are held without due process.

Process due. It's clear my mother wants attention and a daughter's is preferable to an aide's. She cries on the phone and I appear. She apologizes and gradually perks up. She considers my suggestion to hire an aide to help her every morning. "Depends

on the person," she says. I am giving her little time and less consideration, ignoring her obvious decline.

Later, at home, I look over page after page of Chris's blood numbers that I collect each day—no doctors' comments or interpretations, just the facts. I force myself to study them. I see that his counts are only crawling back from the latest chemo. We expected a brisk jog. Has the marrow stopped working? Or if not this time, will another chemo treatment destroy it? Doctors' efforts not doing any good? Hospitals no good?

I can see Chris is worried; I am worried. He has been confined at home all this month, eaten all meals at home, seen no one beyond the immediate family. He rides the exercise bike indoors. He paces up and down the driveway wearing a white mask over his nose and mouth.

By the time I look up it is already 4:30, the low time of day when light dims and shadows creep longer, hard edged toward the relentless, encroaching black. I want the day to be over but it isn't; I want to jump straight to bedtime, no cocktail hour, no evening TV watching. But it's time to flush his catheter line and change the dressing to keep it sterile. I call him to the kitchen table, "We can't avoid it any longer." He sits in the straight, hard oak chair, his back stiff, and, without saying a word, sticks his right arm straight out, palm up on the table. He looks away. If he were to watch me expose the line, he might clench or twitch. "Just relax," I say, to myself as much as to him. He gives me a yeah-right look. I peer at the crook of the elbow where the catheter enters the skin. "It's slid out a tiny bit. The stitches are red." He glances at me, questioning, maybe his look is more a glare—I won't do it right, it will get infected—but says nothing.

Later we sit in parallel recliners, our feet up, our eyes on the flickering TV screen, our minds on the National Democratic Convention and the war in Iraq. We criticize politicians who lack integrity, who seem to care more about financing campaigns and winning primaries than discussing serious issues using "facts" that can be trusted in language that isn't clichéd.

Walls often divide us in the evening—the bright, open, kitchen-

family room where I read or watch TV and the small, cozy den where Chris reads or draws — and often divide our bedrooms, when dump trucks and semis downshifting for the stoplight at the foot of the hill rattle the windows in uninsulated walls and drive me to a quieter room.

Early one morning, I peek in at Chris, still asleep behind the CPAP mask. The hard plastic cups his nose and mouth and tubes connect the mask to the machine that pulses air to keep his throat open. The equipment divides us like a lover. I slip into our generous bed, hardly daring to, but he knows, as always, and flips off the Continuous Positive Airway Pressure designed to save his heart. He turns toward me, inches his arm under my breasts, nestles his face in my neck, burrowing, as always, our breath in syncopation, not in concert. He eases on top, deflated, head-to-toe heat melting the edges of my body.

Life support.

That much is true. Our bodies have instinctively known how to work, no matter how imperfectly, no matter what emotions churned beneath the surface. What if we could trust ourselves more than medical experts and medical institutions and medical instruments and lie together just like this for as long as we can.

■ ■ ■

Contributing to the hysteria in Salem was the absence of local sources of information, such as newspapers, to keep people accurately informed. Furthermore, there was confusion in the county's governing structure as well as in the Colony Charter, concerning taxes, records of land transactions, and accurate boundary lines between townships. This led to many local disputes. +

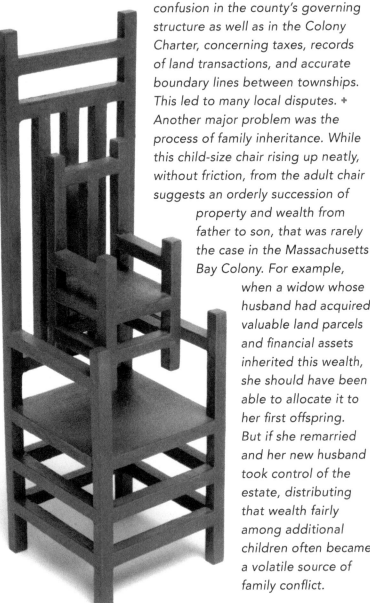

Another major problem was the process of family inheritance. While this child-size chair rising up neatly, without friction, from the adult chair suggests an orderly succession of property and wealth from father to son, that was rarely the case in the Massachusetts Bay Colony. For example, when a widow whose husband had acquired valuable land parcels and financial assets inherited this wealth, she should have been able to allocate it to her first offspring. But if she remarried and her new husband took control of the estate, distributing that wealth fairly among additional children often became a volatile source of family conflict.

Inheritance Chair

August 2004

I

T'S OUR LAST morning at a friend's beach house in Rhode Island. I tell myself to stop drinking coffee, get out of the chaise, and off the deck.

"Let's ride our bikes to the town beach," a bright smile in my voice.

"I don't want to look at the water if I can't swim." I hear his sharp tone. He doesn't look up at me.

He's never wanted to swim in the ocean, especially in Flood's Cove. Maine's waters are "too rocky, too cold, much, much too cold." But skinny-dipping with friends at midnight under a beautiful, starry sky at high tide — when we too were high — Chris was the one leading the parade. I think back to when we left our sleeping children and snuck to the dock, unwilling, or unable, to suppress our hilarity as we stripped and lowered ourselves by the ladder into the dark sea, numbed by alcohol and gradually by frigid buoyancy, whipping up phosphorescence, hugging and chasing each other. I wrapped my legs around his waist and tried to push his head under. Surely we disturbed Aunt Marge, asleep above us on the second floor of her cottage, "The Defiance," but she never shushed us or complained the next day. Perhaps she enjoyed her own memories

of skinny-dipping afternoons with her daughters and me when the Cove emptied of curious male onlookers.

Glancing at Chris, intent on a drawing, I see that after thirty-nine years with a full-bearded husband I have a new husband with a baby-smooth face and wisps of white hair. I never saw his full lips until now, only the thicker lower lip that protrudes a bit, slackens as if pouting. Only my mouth knew his mustached upper lip. Now I see the whole package, his father's mouth and nose, his mother's jowls. He looks more like his brother than I knew he did. Now the Horton face he inherited is revealed beneath the face he constructed. He almost got away with it.

As we were leaving the hospital five days ago, doctors said, "Go ahead, take a break, but remember you are neutropenic, so stay away from people. No restaurants." They also ordered another bone marrow test to check the results of the chemo treatment in July. Chris emailed Dana-Farber for an update on the search for a compatible donor: "Hi, Mr. Horton. Your search is a bit slower than anticipated, as it turns out you have a rare allele (a normal variation in the genetic code in your self genes). We are working hard to find you a suitable donor. We are hopeful to have something for you in the near future so that you do not have to go through another round of consolidation chemotherapy."

"Oh god, now what!" I groaned. What the hell is an allele and why is Chris's rare?

We packed up our worries and our questions, instead of answering them, and headed to Wickford, Rhode Island. And, just as he did in Maine when cancer first struck seven years ago, though feeling much less ferocious this time, Chris woke up with a plan to fill one day then another, where to go and how to get there and, always, what to eat. We learned about colonial and Native American history in Newport. In Bristol, King Philip (Metacomet) was murdered near the "seat" in the rock wall where he addressed his followers. King Philip's War in the early seventeenth century led to the two French and Indian Wars later in Massachusetts and Maine, whose horrors some historians believe bore much responsibility for the paranoia surrounding the witchcraft crisis.

Moonflower. Pencil and watercolor. August 2004.

Grateful for Chris's interest in things, I rarely demurred, yet worried he was pushing himself too hard, and of course he was anemic. He peddled his bicycle like a worn-down windup toy. I rode behind him and struggled to balance at his pace. We spent every moment together, not going off on our own as we did for twenty years on vacations in Friendship, Maine, for another ten years in other corners of Maine, and for the past two summers at Funky Cottage, where, carefree, I was often alone while Chris was painting.

This morning, I leave him sitting at the picnic table hunched over a watercolor of a moonflower, one of several growing in pots on the deck railing. Abnormal night bloomer, it surprised us with one large, pale-lavender trumpet blossom that bows with its own size and weight. He is working quickly to capture its grace, its burden, before it closes again by midday and reopens tonight after we have left.

As always, his synchronous eye and hand recreate a vision. The moonflower blossom emerges in soft pencil in the left foreground.

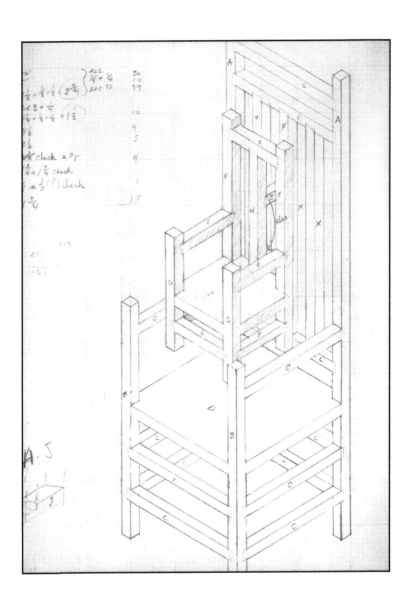

In the middle are large, thick-veined leaves; in the right his own shadowed face balances the withering bloom on the left. Or does his face represent one of the ceramic gargoyles that hang on tree trunks in the backyard. Will they protect him?

I kiss the top of his mostly bald head. "I'll be back for lunch."

"Bye," he says, not looking at me.

I ride the mile or so to the town beach crowded with older people, probably from the senior center nearby, who, not swimming, are collapsed under sunhats in lawn chairs, or strolling, heads bent to monitor their steps. Kids from a camp shriek and splash, chase each other in and out of the water. I walk my bicycle beyond the lifeguard stand, lean it against a trash barrel, lay my pack, shirt, shorts and sneakers on shelves in a stone wall, spread my towel and sink into soft, warm sand. I am anonymous.

Eventually I ease, barefoot, into the smooth, tepid bay and swim, buoyant, relaxed. No water shoes needed here without any punishing Maine rocks. So different, I muse, floating on my back, from swimming in Flood's Cove, if only to compete with Aunt Marge, who eight or nine times a day descended the ladder at the dock for a quick dip.

Parenting our extremely active young boys on vacation in the Cove, Chris and I often stood side by side on the Bungalow porch to negotiate time off. We analyzed the light and tide. If conditions weren't right for him to resume a large watercolor in that year's studio among granite boulders, I could sneak off with towel and poetry books — Sharon Olds and Galway Kinnell were favorites — to one of many hiding places in outcroppings and inlets: Beatrice Bay, the Gut, Pa's Island, or Aggie's Cove; select the smoothest granite cushion; wriggle into a perfect groove; and turn my face toward warm, dreamy space. A trio of old white birches leaned toward the light. At my feet a microcosm in a hollowed-out granite pool, water and mud enough to sustain a tiny community of periwinkles connected by a maze of pencil-thin mud paths, each no bigger than my smallest fingernail.

How much did anyone need.

On our wide, screened porch, still in morning shadow, we could

tell it was 10:00 by Mother Horton's emergence from the wooded Log Cabin Trail. We watched her, in a short-sleeved shirt from her Leon Levin collection in sherbet colors, a brightly patterned "skort," and flimsy canvas flats, as she strolled the open path that curved like a comma, parallel to the Cove, to the weathered Defiance perched on the concrete dock. She carried the denim tote bag she had made, a stripe of ducks marching across it, with its telltale contents: a peanut-butter jar recycled for carrying four ounces of dry sherry. Precious cargo. In bathing suits for tanning, sisters Marge and Julia smoked and drank as they played two or three games of Scrabble, their pillowy breasts spilling over the game board.

On her way back to the Log Cabin, she dropped in on us, her children and grandchildren, to say good morning, check on everyone's well being, and plan cocktails and dinner. Should we gather just for G&Ts or also for dinner? Chris tempted her with another Scrabble game, but she hurried off to prepare lunch for Dad, who spent the morning reading indoors.

Mother Horton's love of the place flowed like the eight-foot tides into the genes of every generation and into me ever since my first night at their cabin in 1965. After she died in 1992, we returned to the Cove with Dad, who was increasingly frail, but the heavy fog of loss refused to lift. Her spirit was still everywhere, especially in the Log Cabin, where for twenty years I ran for a molasses cookie or a brownie, bursting through the screen door, letting it slam, and interrupting her game of Solitaire while smoking.

Where, sometimes, not often, when she, Dad, and Aunt Marge were in the mood, she invited me to witness Tip the Table. They set up the card table, placed all thirty fingertips on top — I checked to be sure — and that table started to inch around the room, slowly at first, like the arrow on a Ouija board. Once, when it veered in my direction, I pushed my chair back, then farther back until that damn thing had me pinned in the corner; I, victim, yelling, "Stop!" and the three of them laughing, enjoying the magnetic energy they shared.

When the game player and sherry drinker, the zucchini-casserole and blueberry-pie maker, the curtain sewer and cushion coverer

died, our trips to Flood's Cove dwindled. How much did we need? Only that place, that time, devotion to a particular environment our inheritance. The difference between us was Chris's productivity, a watercolor to exhibit, perhaps to sell. I spent my time alone breathing in spruce and rockweed and mud, the sun's heat cooking the mixture, pungency rising.

Now, in these fearful months a decade later, every moment alone is tinged with guilt. How can I take a break—dash to Vermont with my sister for a day, attend a friend's daughter's wedding, go swimming alone. I should stay with him, safely side by side.

After lunch, we pack up to leave our beach getaway. Chris props his watercolor of the ephemeral moonflower on the dining room table as a thank-you gift, and we drive west to Connecticut. Storms play with us, first Bonnie, then Charlie, the brunt of severe weather tracking over Rhode Island. Should I have moved the pots of moonflowers from the deck railing? Won't heavy winds send them crashing to the ground?

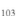

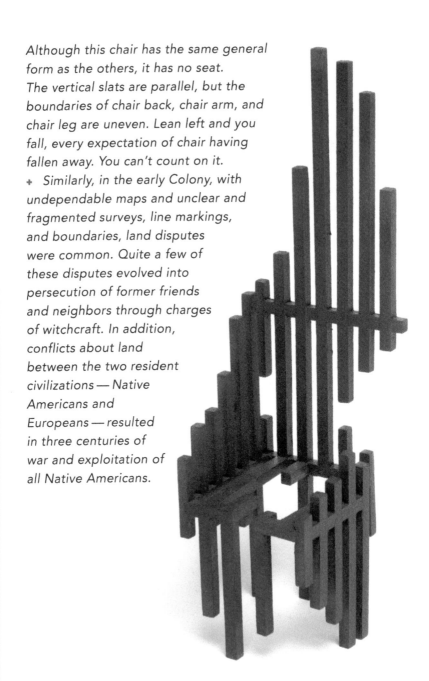

Although this chair has the same general form as the others, it has no seat. The vertical slats are parallel, but the boundaries of chair back, chair arm, and chair leg are uneven. Lean left and you fall, every expectation of chair having fallen away. You can't count on it.

+ Similarly, in the early Colony, with undependable maps and unclear and fragmented surveys, line markings, and boundaries, land disputes were common. Quite a few of these disputes evolved into persecution of former friends and neighbors through charges of witchcraft. In addition, conflicts about land between the two resident civilizations — Native Americans and Europeans — resulted in three centuries of war and exploitation of all Native Americans.

Boundaries Chair

August 2004

T HE HEAVY STORM dogging our trip home from Rhode Island has slipped by New England. Leaving Chris to take a nap, I hurry to The Gables and wave down the head nurse in the parking lot.

"How has my mother been this week?"

"Oh, she's had some confusion, and it might be a sign of a UTI (urinary tract infection). I think you should get a urine sample and take it to her doctor."

"Okay."

"One of the aides reported she had scrambled an egg for her as she usually did. Your mother snapped, 'I hate scrambled eggs,' and dumped it in the sink. After lunch, she wanted the girls to walk her back to her apartment. 'They walked me here and I want them to walk me back.'" The nurse laughs, "No one walked her to lunch because she doesn't have escort service."

She doesn't wait for me to respond. "Another night recently your mother went to dinner and sat at a different table, insisting it was hers, not remembering where she has sat for years."

I listen to this litany of regressions. The word for them is dementia, my mother's mind slipping beyond its rational boundaries. Where is the mother I have always known? The

mother who taught me to dance the Charleston in the kitchen when I was two, lowering the needle on Benny Goodman or Glenn Miller and turning the volume up just enough, knowing how loud to crank up the swing and how hard to thump our feet on the linoleum, shiny and slippery as ice on Hall's Pond. Dad in his general store downstairs should not hear the sounds of his wife and daughter jiving upstairs.

Where is the mother who taught me by the age of two to memorize much of Mother Goose and all of "'Twas the Night Before Christmas"? The mother who rolled my long blond hair in "rags," cotton strips ripped from old white sheets, for pipe curls she tied with carefully pressed ribbons that matched my socks rolled down once. Mother's perfect doll, ready to walk next door to the Congregational Church, the only church in our small village, with my grandparents and sit with them in their special pew, third from the front on the left, Grandpa on the aisle, then Grammy, then me. The mother who cautioned me not to swing my legs, not to kick the pew in front of me in that holy place.

The mother who later taught me a mantra, "If God is with me, who can be against me," when I suffered from stage fright in high school. The same mother who, waiting patiently for me to come home from a date with my steady boyfriend, sat on the radiator to keep warm in the late hours of winter Saturdays where she could reach the porch light switch and flick it off and on, off and on, impatiently, if we lingered too long in our long goodnights. That mother's long goodnight is coming, but I don't know it yet. Where is she going without her family, without me?

At home, I listen to Chris complain about a cyst on his waist irritated by waistbands and sitting positions just when his blood counts are almost normal and he feels more energetic than he has in six weeks. "All I want is to eat a salad and go to a movie, but I still can't do either." I look him in the eye with a slight nod, tighten my lips in an "I know, I'm sorry," and escape to sort the pile of mail.

In the clinic, he's quietly sketching while an IV antibiotic tackles the infected cyst. My mind starts ranting. Why has it gotten to this

point? He should have had it removed six months ago. He should be more proactive, I complain silently, as I hand a crossword puzzle back to him, unable to concentrate on it. He takes it and puts down his sketchbook. We are always playing catch-up, rather than the reverse, our decisions out in front. Just as in 1972, I realize with a start, when we escaped the risks of communal life, confused about boundaries, too afraid our marriage would not survive that dark wilderness where we'd tripped on dense undergrowth, snagged by hidden thorns.

[*June 1972*]
Cummington Community of the Arts

A RECURRING ABANDONMENT NIGHTMARE, dark enemy — witch's specter, familiar — jolted me awake, in shreds, sweating, crying; paralyzing fear that Chris was pacing it out, doing the good father bit, just waiting for the moment when he could leave me without too much guilt, when his parents were dead, when the boys were "old enough." I knew it. If he died today — I believed the worst — I wouldn't be sure he loved me.

But coming into consciousness in the upstairs studio wing of Frazier House, I heard his rhythmic snoring next to me in the not-big-enough bed. We were still there, together, our two little ones asleep.

> *Dark and quiet the nursery*
> *rhymes have gone to bed.*

Writing in my journal, I realized I needed time away from my family, and other women made it possible. A mother with a two-year-old offered to monitor our boys' naps, and our neighbor across the road, Olive Thayer, offered — did I ask or did she offer? — a spare bedroom I could use a couple of afternoons a week. I lugged my typewriter, the red Smith Corona that had known only college

lit-crit papers, and a bag full of inspiration — poetry by Denise Levertov, Adrienne Rich, Sylvia Plath, Anne Sexton — up the stairs to a room under the eaves with a single bed, simple wooden table, and straight chair.

From the one small window, I could look south toward barns and hayfields, away from the community, but my mind persisted in jumping back across the road. Are the boys all right? What's going on? What is Chris doing?

"Like a marshmallow ballooning in heat," I wrote, "my body rises to yours, so tired with living that words come slowly or not at all. But the living is right, it runs through tall grass, stumbles on unseen briars, pauses, smiles, shares a poem, a piano."

Eventually, more at ease with silence in that tiny room, I began to write, simply, by describing what I saw beyond the screen. A vine with large, heart-shaped leaves, having crawled up the side of the house, reaching the window, stepped away, curled into air, its camouflaged blossoms like small, pale green pipes. "Dutchman's Pipe," Olive said, as we sat together over tea at her kitchen table. In her eighties and under five feet, nearly as round as she was tall, long gray hair wound at the crown of her head, still drawing and painting, reading, volunteering, her lively conversation infused me with energy.

"And look at this mushroom!" she exclaimed one day, pointing to a beauty she had brought inside to identify. "It's a deadly Amanita, with many showy varieties. See how delicious it looks, and tender? It peels exactly like an edible one. You must wash your hands after just touching it." Appearance versus reality a useful concept, I thought, for examining a mushroom or a marriage or the people around you. What is safe, what can you trust?

I showed my attempt at a poem about that "Dutchman's Pipe" to the poet in residence that summer, who thought it was successful. She was enormously encouraging, just being nice, I told myself, refusing to believe her, shame essential to my sense of self. I still regret turning away from the opportunity to work with her.

I had my own challenges, clearly, but that summer the whole community was struggling with boundaries in endless discussions

that drained everyone's time and energy. Four years earlier we had designed CCA as a summer-only educational experience, but, in 1972, a few members saw it otherwise and proposed to turn the place into a permanent artists' retreat. They wanted to live there year round. They would fix it up, make it better. In exhausting, late-night meetings, Chris felt increasingly rejected, defeated. In the end, the Board of Trustees in distant Boston accepted the slim majority vote for change, and work began to winterize the outbuildings.

The question for us was whether to move to Massachusetts, change our address from Lovely Street to Potash Hill Road. Would we sell the old house we were remodeling, where we were building a studio for Chris in the barn? Would he leave the tenure-track position he loved at the Hartford Art School, or endure a very long commute? Would we break the pact we had made when we hunted for our first home three years earlier: to live in a village where we could walk everywhere — school, supermarket, doctors' offices, pharmacy, bank? Even in rural Vermont my family had lived in an apartment over my father's general store in the center of things. Chris had grown up in a town of similar proportions in New Jersey.

We decided not to move; such a life would be too remote. I would not be a station-wagon-driving mother, tethered to kids and groceries, although such skillful reasoning masked the underlying terror of that recurring nightmare. Convinced our marriage would not survive the sexually free milieu of communal living, I — did Chris too? — had to face all the confusion and turmoil escalating on so many fronts in the "liberated" 1960s and '70s.

We struggled with the idea of community just as our seventeenth-century ancestors had: different ethnic and racial groups attempting to co-exist; roles of women shifting rapidly in a new era and in a violent frontier; persistent wars that terrorized civilians; political assassinations as well as thousands of deaths of men, women, and children.

In the 1960s, every sign of 1950's stability that had seemed so permanent was destabilized, suddenly. As a result, just as in

every historical moment of terror, Chris and I retreated to the age-old domestic myth that circumscribed our gender roles and made us feel secure in a most insecure time. At the end of four years as directors of the Cummington Community of the Arts, we packed up confusion with our labels — husband, father, mother, wife — and drove them all home, retreating to the familiar, a middle-class existence in a small mill town. Home. Chris started a new semester at the Art School. I plunged with conscientious energy into mothering the squirming exuberance of two little boys who sat still only when we read *Curious George* or watched *Sesame Street*.

Everything, and nothing, the same. With incredible power over each other's lives, how would we use it? For calm submission, not turbulence or even challenge, not drama. No public accusations or witch trials pitting us against one another, we withdrew from an exciting, potentially revolutionary, new world we had created and believed in, our fear of conflict and change shrinking our world back to one that was both familiar and dreaded. We succumbed, soothed our babies, and in that necessary loving, taking care of them we took care of ourselves, our family. Wounded, but not fatally, we drew new boundaries of tolerance.

But before long, I began pushing against what I saw as a stifling, housebound existence. Driven to earn a living by what felt like poverty, to once again see my name on a paycheck, as Mother had advised, having reminded me early on that marriages don't necessarily last, I enrolled in a tuition-free University course, The History of Women in America, to satisfy the history requirement for teacher certification. The professor from Yale lit up the classroom with passion for her subject, and I devoured her reading list, a historical survey of primary source speeches and articles written by women. Famous names: Susan B. Anthony, Lucretia Mott, Amelia Bloomer, women in the nineteenth century again challenging patriarchy, as Hannah Dustin had before them, refusing to submit.

In particular, Elizabeth Cady Stanton's famous, earnest speech, "Solitude of Self," her final public address as president

of the National American Woman Suffrage Association, in 1892, seemed directed at me. "The point I wish plainly to bring before you on this occasion is the individuality of each human soul. . . . The strongest reason for giving woman . . . the most enlarged freedom of thought and action . . . from all the crippling influences of fear — is the solitude and personal responsibility of her own individual life." Her message was not unlike the challenges the witch trials posed in 1692, when an individual mind, whether magistrate or girl-accuser, had the power to take a life or to save a life.

I remember what Chris had said: "I can't tell you what to do; you have to figure out your own life." Maybe I could figure it out. Reading women's history liberated me from the fifties culture of femininity sold in magazines like *Seventeen*; its instruction in soft sexuality, the pretty girl who slept in fat, pink plastic rollers, as I had; the girl who wore crinolines and poodle skirts, matching sweater sets, and a circle pin, as I did to fit in. Thinking about my experience in the context of women's history helped me understand those confusing, contradictory decades. Reading Kate Millet, Betty Friedan, Gloria Steinem, and others, devouring *Ms.* magazine, the emerging vision of a female self in the early 1970s seemed more solid, more right than the reductive, traditional model. Being born a woman, slave to hormones and homemaking, could mean much, much more than it had.

Yet, of course, fashions change with the decades, women's bodies are forever appropriated, and rules for bodily display are as confusing now, as then. But knowing more about historical and cultural forces, a strong, courageous woman can decide where on the gender continuum she wants to balance herself. I remained a wife, mother, and teacher, but my perspective on those traditional roles had radically altered. I like to think that knowing a little history changed the way I mothered our sons and the way I taught both male and female students for the next thirty years, as I tried to be more mindful of Stanton's wisdom and to encourage others within my sphere of influence to take responsibility for their own lives.

August 2004

AT HOME IN stifling late-afternoon heat, I see Toby sitting on the low wall in a corner of the patio, hunched forward, elbows on his knees, staring into the distance. I step down off the deck and sit next to him. "Are you thinking about what's ahead?"

His back stiffens; he doesn't look at me. "No, I've been thinking about the past . . . about Dad's life decisions." I resist being a nosy mother. "Why Dad stayed at that school and didn't go anywhere else, why this town, why he never moved on."

Though tempted to challenge his definition of moving on, I stick to the topic. "He had a couple of interviews, but didn't think the curriculum at either of the schools was as interesting as the one here." Toby falls silent. Of course I was rationalizing, again, rather than admit the real reason, avoiding risk the real reason, the crippling influences of fear having stubbornly reinforced the boundaries we had set for our lives.

Annoying gnats chase me indoors to an old wicker chair, where a rasping electric fan feathers humid air across my face. I pour a glass of iced tea, squeeze in a sliver of lemon and stare out the window over the sink, munching on half a turkey sandwich left over from yesterday, or the day before. Standing here, I see decades of evenings when Chris, in plaid flannel shirt, cargo pants, and work boots, six-pack in hand, headed across the yard toward the barn, receding as he climbed the stairs to his studio, his back to me.

The island he has lived on — art studio, art school — is now hospital, where, still tightly bound, we are dependent on an indigenous population of medical experts and their minions, not on ourselves, to orchestrate our fate; just as colonists' lives were dependent on their relations with Indians, their reality interpreted and enforced by ministers and magistrates. I think about how I, born on the cusp of air and water, often wanted change — isn't the grass greener? — but Chris didn't, his Capricorn hooves firmly rooted. He has been content here, anchored. While we spent summer months in other places — England, Massachusetts, Maine,

even living in Italy for a year before we had children — they were quick trips out to sea. Each time our home receded into the distance, it reeled us in. Now it's the reverse: well into his next adventure, Chris drifts toward the horizon on his own as our home anchors me.

█ █ █

Abduction by Native Americans was a frequent occurrence during the so-called Indian Wars of the seventeenth century. These actions terrified the small frontier settlements and threatened the very survival of the Colony. During the King Philip's War (1675-76), twenty-six towns in the Boston area were attacked and burned by the Wampanoag, Narragansett, and Nipmuc tribes. Thousands of people were killed. Most of the hundreds who were captured were taken to the dense wilderness, and many died en route. Those who survived were eventually repatriated through ransom or material exchange. The brutal events experienced by some of the girls who were abducted may have resulted in their suffering a state of surreal paranoia and contributed to their becoming early victims and accusers of bewitching activity.

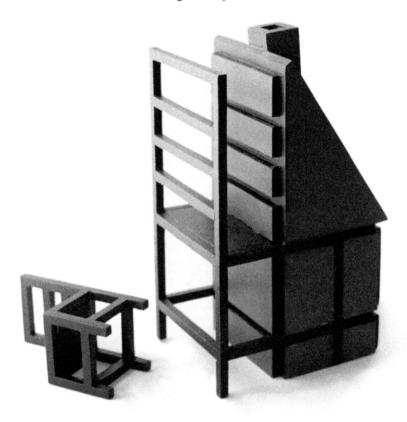

ABDUCTION / CAPTIVITY CHAIR

September 2004

F ROM HIS HOSPITAL bed Chris hands me the text and Pete's new design for the Abduction/Captivity Chair. It's the first time I've seen it: a small chair pulled away from home and tossed on the ground representing thousands of Puritans in the Massachusetts Bay Colony who were abducted for ransom during the Indian Wars.

I think about my connections to that history, especially the story of my ancestor, Hannah Dustin, who, in 1697, five years after the witchcraft trauma, survived captivity, escaping with ten scalps as evidence of her trials. She received a monetary reward and much notoriety, having been elevated to heroine status in one of Rev. Cotton Mather's stirring sermons. Mather's goal, however, was to use her as an inspiration to rouse the general public to fight back against the very real threat of annihilation of the colonies.

I ask myself what influence, what force, what "other" abducted me by physical or intellectual or emotional force from my home? I remember always wanting to escape my family, my town. Highfaluting educational goals abducted me, sent me from that small-town, Congregationalist, Republican, white, working class culture to a magic kingdom in an enchanted forest of the liberal

arts, where I was rebaptized by literature, music, history, philosophy, and religion. The brainwashing took, settled deep within and never paled. I returned to the Congregational Church of my childhood only for our wedding ceremony. I was probably the first in my family (and still the only one?) to register as a Democrat. How easy it was then to reject everything and everyone I had known, to want more, more, more.

While I'm lost in thought, Chris, cancer captive, emails his doctor at Dana-Farber the latest discouraging news about his condition. "My leukemia has returned about eight weeks after consolidation therapy. Will this prohibit any possibility of a transplant? Any recommendations you may have at this point . . . will be very much appreciated. Sherry and I are still going to fight this thing hard."

How can we possibly fight, fight with what? cries my despairing mind. We have become dependent on medicine men, "gods" who offer salvation.

"Mr. Horton," the doctor replies, "We need to proceed to transplant even without a matched donor, using the best donor available . . . [It] . . . certainly increases the risks of transplantation, but I am afraid this may be the best shot we have."

We wait, what else can we do. Risk averse, we will risk a transplant. We don't even think, much less discuss, the alternative — give up and go home. No submission to death.

CHRIS ASKS, "Will you read this draft about Abu Ghraib?" We had been reading and talking about the news of torture in that Iraqi prison.

"Sure." Entitled "Humiliation," it is, as far as I know, his first attempt at a political op-ed. I mark a few strong lines:

> *The ongoing revelations concerning Abu Ghraib call into question our own reputation as a moral, just, and sensitive society . . .*

> *Who originated the practices of forced consumption of*

*pork and alcohol, shaving facial hair, and confrontation
with dogs, of which Iraqis are profoundly fearful?*

*One detainee subjected to this humiliation said he
could not possibly return to his family or society. Do we
have any sense of his degree of shame? Our leaders
still seem to be in denial about the amount of damage
that our use of humiliation has done to our standing in
the Arab world.*

The practice of humiliating Iraqis in retaliation for 9/11 resonates
with the persecution of individuals thought to be witches. In both
cases—and in many others in history—scapegoating innocents
was a tactic that would hopefully gain redemption for authority
figures responsible for unjustified bloodshed. Blame the victim.
I help Chris with the letter, touched by his outrage and by the
debasement of his own powerful body.

His experience with leukemia—shame, fury—may be similar
to the experiences of Iraqi prisoners and of the abducted in Salem,
but he puts words only to their suffering, not his own. A hospital is a
prison, just as the body is a prison guarded by "experts" with total
control over your life. If you want to live, you succumb, powerless,
humiliated.

ON SEPTEMBER 8, Chris is re-admitted to Dempsey Hospital for
salvage therapy. That awful term. He asks me to bring his big
sketchbook and drawing pencils and pens so he can work on
the Abduction/Captivity Chair. We talk about how the accused
"witches" were held captive by a young judicial system whose
regulations and procedures were still unclear, often in disarray;
how the accused were interrogated, stripped of dignity, betrayed
by neighbors and so-called friends, even family members, in
order to preserve a system that was failing to protect their "new
world."

Then Chris remembers an Art School event at the University

tomorrow. He urges me to attend since he cannot: an art history panel discussion about the nude in art, "The Charged Image." He sees me hesitate, looking down at the floor, doubtful about going, and says, "You know what Kenneth Clark said in *The Nude*, right? That it's okay to have 'a slight bit of tumescence' in front of a work of art."

Smiling, I meet his gaze. "Art a turn on for men? Okay." We laugh a little.

He pauses, "Isn't it interesting that the female viewer has been left out of most discussions of art?"

My mind clicks onto a favorite topic: women in patriarchy. "You mean women weren't even looking at art, much less judging it? And so they might have preferred different works than the ones that have endured in art history?"

He agreed. "Most likely. I'm sure this panel will have revisionist opinions about 'the charged image'. I wish I could go and ask a question."

"I certainly wish you could. I'm sorry you can't." I don't want to go without him to the place where we both worked for decades; I don't want to walk across campus and sit in Wilde Auditorium; I don't want to face the people I might see, who might know Chris or me, who might know. At midnight I decide I'm going to cancel, but then I worry about explaining my change of mind, my fear of exposure, my sadness in full view like an imperfect body, my shame a "charged image." But in the light of day my fear entirely dissipates in the genuine smiles and hugs from so many former colleagues in the Art School and the College of Arts and Sciences, where I was Director of the Center of Reading and Writing and an adjunct instructor in the writing program.

In my role as teacher, I was committed to watching the light of understanding spark in students' eyes when a specific skill helped them succeed in their courses. Every interaction with an individual and an entire class was a challenge of connection, one in which I probed their thinking, as well as their attitudes toward learning, until I saw a chance to enter and try to make a difference. Focusing on the quality of a student's thinking, reading, and writing, I could

quickly see the gap between what the assignment called for and what a student had written; between how the student was studying and what would be necessary to ace an exam. I taught the jargon of academic disciplines, how each field of study has its own "foreign" language to learn. I showed them how to break down dense research paper assignments into more manageable bites. I insisted students use their own language in their writing and demonstrated the difference between plagiarism and responsible text citation. All very challenging and ultimately satisfying work that I enjoyed for decades.

THAT NIGHT I WAKE UP half dreaming, comparing men's bodies. Chris, in his sixties, his shoulders slightly stooped, his head thrust forward a bit, looks like a taller version of his father. Then, still dreaming, my mind skips back to high school and my first experience touching a male body, loving, yet refusing to marry him, my mother's ambition for me to go to college and marry an educated man more powerful than my attraction to my boyfriend's wide shoulders, large brown eyes, and honey skin. I keenly felt the conflict, at eighteen, between love and marriage and higher education, confused about ambitions above and below the neck.

Still thinking about bodies, I flip back to 1971, when Chris and I talked about what had happened at Cummington, my heart pounding. He had said that her body was a female equivalent of his, large-boned, sinewy. How ugly, how humiliated, how alienated I had felt with skinny arms and legs and large, leaking breasts, my body offered to our baby rather than to my husband. I imagined him lying in a field with her, she so young, a female mirror of his ego, the two of them sketching nude portraits of each other, admiring each other's perfect, matching contours. Charged images.

My arms had enclosed our infant son, and I'd whispered to him that he was a perfect love. Perhaps in bearing children I could endure, as women always had, the inevitable pain of relationships

with men. I wonder if my mother, disappointed, had ever drawn me to her, if I, her firstborn, might have comforted her.

AROUND 9 P.M., doors locked, outside lights turned off, someone bangs on the back door. It's Toby, a surprise visit from Syracuse. Hoping his father will write comments in his sketchbook as he always did for his students, Toby hurries to the hospital to see him and tries not to be disappointed when the art professor has little energy for thinking and talking. We understand this drug treatment has been more debilitating. Still, Chris listens intently as Josh and Toby, sitting on either side of the hospital bed, answer his questions about their classes. "Just do your work," he tells them. "Live your life. Don't change anything because of this."

Right, sure thing, my mind mutters, as I sit behind my three beloved men, quietly observing their conversation. His death isn't supposed to affect them. They should steel themselves against loss and grief. Carry on without any hint of PTSD. Plant the fields, rebuild the house and barn burned to the ground. Be good citizens. Obey.

EMAIL GOES OUT from Dana-Farber: "Chris Horton has an A-allele mismatched donor requested for Oct 11-13. PBSC [peripheral blood stem cell] mini collection."

I go to see him and pace around, unable to sit down and relax. We don't talk about much, then find something to argue about in a newspaper editorial about whether the soul is separate from the body. "It isn't separate," I say.

"Yes, it is. The body dies, the soul doesn't," he asserts.

"The soul is a concept, an idea in the mind like everything we believe, so whatever happens to the body and mind happens also to the soul." I'm cantankerous. He shakes his head.

Later, reading *The Barn at the End of the World: The Apprenticeship of a Quaker, Buddhist Shepherd*, I stop where author Mary Rose O'Reilley quotes Olga Broumas: "The body is

that part of the soul perceptible by the five senses." I read it to Chris.

"That's what I think, see? Maybe the body is a transient thing — seen, smelled, felt, tasted — that comes from and returns to soul, which is cosmic rather than individual," I say. He just looks doubtful, refusing to argue any more. But I keep thinking about it. If the body is transient, surely we need to care for it with tenderness. How obsessed we are with body. How violently we use it to humiliate and control the present and the past, all of history teeming with torture and death, all in the name of victory over evil, in the name of peace. Think of Salem, think of Iraq, think of the treatment one very dear body is undergoing in an effort to extend his life.

ONE MORNING LAST SEPTEMBER, a few days before the end of our four months in Maine, I threw open the kitchen door leading to the large shed porch and startled a small creature winging overhead into the darkened space. I slammed the door to prevent its flying into the kitchen and stared through the window. What was it?

I waited, holding my breath. Soon, a small bird, perhaps a sparrow or warbler, lighted on one of the high crossbeams, trapped indoors. I went outside and propped open the two large shed doors, expecting it to find the exit, but it flew the peak around and around, rested briefly on a beam and turned full circle, wondering where it was. It needed an exit strategy, and so Chris dropped a trail of breadcrumbs, like Hansel, leading outside, with no immediate results. The bird continued circling overhead, not understanding it would need to fly lower in order to escape. It eventually plopped to the floor and stepped to the sill, no appetite for breadcrumbs.

It was a bird I didn't know, a beautiful olive green with a darker patch on the crown framed by black stripes, its breast barred, brown and cream. After a few seconds, it didn't fly away, but hopped to the ground and walked casually across the lawn and around the front of Funky Cottage, striding out of danger just as

a mischievous boy might sashay off, nonchalant, hands in pockets, enormously relieved to have escaped.

I grabbed the Audubon guide and read about the Ovenbird: "More often heard than seen, it sings a loud and repetitive TEAcher-TEAcher-TEAcher, rising and becoming more emphatic. . . . The song sounds like two stones being tapped together harder and harder."

I looked up Robert Frost's "The Oven Bird," which concludes:

> The bird would cease and be as other birds
> But that he knows in singing not to sing.
> The question that he frames in all but words
> Is what to make of a diminished thing.

That September day there was no characteristic wave of stone-tapping for the man obsessed with stone, no emphatic TEAcher-TEAcher cry for the benefit of two teachers. Just one more silent, "diminished thing" stepping into one more moment, free.

CHRIS'S TEMPERATURE IS 101.5. Shocked, we take it again and it is the same. Rather than wait eight hours to see if it falls, we call and speak to a doctor, who says, "Come to the ER." We obey. At 10 P.M., his temperature is 103. They wheel him off for a chest x-ray.

He is draped in white sheets, soft gray and white beard and hair now a quarter-inch long; eyebrows and big brown eyes and beak nose look the same. Or is it his father I'm thinking about, my father-in-law trying to say goodbye three years ago on another floor of this hospital.

I write in my notebook: Living inside Chris's body for five months. Living alone after he has died. I don't belong anywhere, with anyone or any group. I, abandoned. I want to get it right. Was I happy? Did we have a happy marriage? How will I write it?

This day is most unhappy. The bone marrow test shows the blasts have returned. Leukemia may be growing through the chemo and may prevent the chance to go to Dana-Farber. Chris says, "I've

had such a wonderful life." Struck dumb, I can't respond to such a statement. I look at him like the idiot I am and lower my head, refusing to accept his implication that it's over.

He wants to dictate a plan for posterity. Dutiful, I write it down. "Toby is to carve our names into three red sandstones: place one with 'Chris' in the Saddle River behind the house where I grew up; one with 'Sherry' in the Tabor Branch of the Waits River behind the Vermont house of your childhood; and one with 'Chris & Sherry' anywhere in Muscongus Bay (Maine)."

The perfect, beautiful symmetry of an idea. I look up at him, wondering whether his name and mine will disappear at different rates in different bodies of water. This idea so different from the traditional concept of memorial stones that mark where bodies are buried, lined up alongside family members and whole communities in a special location, an area with no other purpose than to display the dead behind a fence that imprisons them for eternity. Honoring the dead by keeping them captive. It's a strange concept.

In contrast, our individual memorial stones will be separated, returned to the places that nurtured our childhood, while the stone we share will slowly erode, submitted to an island-strewn bay in mid-coast Maine, an enduring symbol of our love for that place. Our commemorative stones will be distant from whatever happens with our bone dust, all that remains; our brain matter and all soft tissue long since airborne molecules far from any reference to the tangible, visible world. Free.

Jail conditions were abominable. At least four, and possibly seventeen adults and children, are known to have died while in jail. Many others suffered great deprivation and trauma. Family and friends could visit prisoners, although the distance to Boston made visits there difficult. Information shared among the accused prisoners and with visitors, who brought news of accusations, trials, and convictions, surely ramped up the panic and paranoia among all. The magistrates often interrogated the accused in the dungeons, not an environment conducive to truth and fairness.

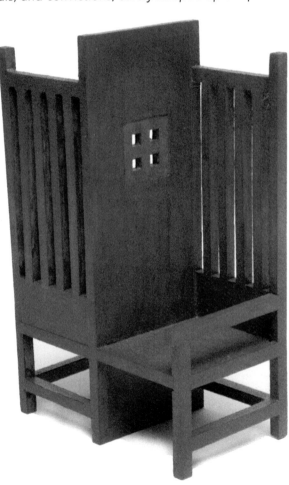

Jail (Gaol) Chair

October 2004

CHRIS IS ON his tenth lap around the oncology unit when I arrive this morning, grab his hand, my eyes wide with surprise at the transformation of his skin tone from pallid to pink. "Look at you! Wow!"

"Yeah, what a normal temperature will do. I even had cream of wheat with peaches for breakfast." Victory on a crisp October morning.

He emails his artist friends: "Sorry I haven't been in touch, but the last month has been a real knockdown. I feel like a yoyo, getting treatment to kill the cells, other treatment to bring them back. If this chemo kills enough of the leukemia cells, we can go to Dana-Farber. It will depend. . . . I miss talking with you all and seeing all your ugly faces, although right now I think I'd take the prize. Keep the art going, I do in my head. Would you please get a small rock from one of your favorite places and send it to me or drop it off at the house? I'm asking all my close ones to do this. Best, Chris." He rides the stationary bike for five minutes then vomits in the sink next to him, relieved it is right there.

He works on the sturdy Jail Chair, which represents the power of the justice system, the high backs of the two seats like bars of a cell,

two incarcerated bodies secure behind a solid wall, similar to the Witch's Keyhole Chair, the tiny holes just large enough for mouths to whisper with stale, desperate breath.

On the Prilosec calendar, I highlight in yellow the tiny squares of days we've spent in the hospital. Chris counts them: seventy-two days in six months. We marvel at the blank spaces during the summer when he was at home, all of June and August, some of July, but we were treading water, not swimming, living with high-grade anxiety about what to eat, what to do, where to go, and what would happen. Precious time wasted, locked in worry's internal, inaccessible prison without a key.

I sit and scribble while he naps. A quiz about marriage emerges; nothing I'd planned, it just came to me. It's like a parody of a quiz you might find in *Cosmo* or a similar magazine. I take the quiz, eager to know how I will answer these questions.

The Marriage Quiz
Check one or more responses. Two points for each answer.
Perfect score = 16.
Good? Yes. No.
Happy? Yes. No.
Contented? Yes. No.
Fulfilled? Yes. No.

When I see that yes and no are equally correct and should both be checked to obtain a perfect score of sixteen, I understand the absurdity of the exercise. Reality in the abyss between yes and no. A complex ambivalence describes my perspective, as if the partners in this marriage have been indicted for being dutiful and practical. Convicted and sentenced to leukemia. Six months and counting.

I SLIP INTO Chris's hospital room, nearly dark without the blinding overhead lights on. He turns toward me, always sensing my presence. "I had a bad night. My nose bled from 2 to 6, great

clumps down my throat and now I'm having bloody diarrhea. They're testing it." In the midst of this long day of concern about excessive bleeding, Josh and Allison come by for a brief, surprise visit to announce they are pregnant. "Six weeks," Josh says, married less than a year, our first baby to become a father, a gift for his father, I'm guessing. We are amazed, we wear happy faces.

Driving home later, I think about Josh's carefully planned birth after we'd been married for three years, in mid-January 1969, the day after my long straight hair was cropped short in a Mia-Farrow-in-*Rosemary's-Baby* haircut. We were living in a small apartment built in one end of a large old barn, miles from a main road, but my labor was long, fortunately, and we made it over the mountain to the hospital at around six in the morning. Twelve hours later, Joshua was born naturally with the wonder of Lamaze breathing techniques and an invaluable, attentive nurse whose experienced hands on my abdomen anticipated a contraction before I knew it was coming. What a team we were, Chris panting and blowing with me and keeping ice chips wrapped in a cloth between my parched lips. I remember the gurney careening down the hallway, barely making it to the delivery room in time for the infant to bolt into a ghostly, antiseptic space inhabited by masked aliens. Our child was a perfect whole — ten fingers and toes — and wholly male, all six pounds and twelve ounces worth. How we hugged and cried.

On the trip home a couple of days later, terrified because the OB nurses weren't going with us, I was even more terrified when Chris left me alone in the car at Woolworth's, and most terrified that the garish, red-orange, psychedelic-print fabric he bought to line the bassinet would drive our newborn insane. We hurriedly prepared the large wicker basket, a Horton heirloom, we had painted an apricot shade. How ill prepared we were — even though Josh had not arrived early — for everything: sleeplessness, breast infection, the whole newborn reality. Who is prepared?

The winter months wore on. Chris began a new semester of teaching. I tried but felt I failed to comfort our colicky infant. How to interpret the incessant wailing? How to survive alone, hibernating

in a tiny apartment in a snow-bound barn? My only option, after hearing the drone of plows, was to bundle Josh close to my chest against the icy air and pace the narrow, hilly road.

I CALL the main desk. The nurse says, "He has blood issues."

"I know. Is he awake?"

"Yes."

I call back. "Hi, honey, how are you?"

"I'm holding. The doctor will be in tomorrow morning to see what to do."

I dream all night, kick the covers knotted around my feet, thrash to pull out of one horror, turn over, grab Chris's pillow, curl around it and sink into another abandonment nightmare. Eventually, flushed, heart pounding, I lurch awake, furious, furious that a stem cell transplant wasn't available months ago when Chris was much stronger. Why wasn't it? I'm so angry I see the medical system only as judge and jailer; foe, not friend, not healer.

Finally, doctors announce that, having done the best they can to beat down the immune system and destroy the leukemia, he is ready to go to Dana-Farber. We have been waiting for this trip since April, our only hope — not for a cure, they never use that word — for a longer survival. But six months later, I (do we both?) bear the burden of suspicion, suppressed, always suppressed, that it is all too late. We store fear, rage, and doubt in baggage bound for some other country.

Instead, smiling hope is what everyone sees in our faces. How Chris does it, I don't know, but while waiting to go to Boston, he distracts us with the alphabet game. And so we play it, then he dictates an email message to friends and family. "When some of us were kids, we played a car-trip game called 'I packed my bag for Boston.' Each person had to repeat each item in alphabetical order, adding a new one at the end until someone failed to repeat all the items correctly or, rarely, when all twenty-six things were recited by one person. Did you ever play this game? Anyway, Sherry and I did today."

The truth is all of these words are his. I am numb and dumb, obedient scribe playing along.

"We packed our bag for Boston, and in it we put Ambition (time to spend, projects to do, people to see, and places to go together), Beauty, Care (superb care from John Dempsey Hospital/ University of Connecticut Health Center), Determination, Energy, Family and Friends, Gratitude, Holbrook (my father), Inspiration, Julia (my mother), Kindness, Love, Marriage, No thing, Optimism, Pleasure, Quietude, Rebirth, Sons, Truth, Unselfishness, Victory, Wisdom, eXertion, You, Zest."

I marvel that a philosophical mind facing a harrowing journey at the end of life is able to produce only the most positive words, determined to make the most of our time together. I marvel at the abyss between our moods. It's as if I'm the miserable patient, the sick one who sees only doom, and he's the healer lifting us up, carrying us forward, bent on survival, or if not survival, an approach toward death consistent with his approach toward life.

I AVOID the loading process at the hospital where Chris is strapped on a gurney and tucked into an ambulance that will sway onto 84 east and the Mass Pike, focusing instead on the details involved in leaving home: stop mail delivery, cancel newspapers, and pack for however long—I don't know how long—we will be away. Thinking weather and words, I pack my VW with fall and winter clothes and a bag of books. I take everything in order to want for nothing. I fumble with directions, take the wrong exit in Newton, twist back onto the Pike and off at the correct exit. Finally, after descending into the underground parking garage at Brigham and Women's Hospital, wondering if it is safe to leave the car full of stuff, I inquire where a new patient would be and enter a cavernous waiting room off the main lobby. No one is at the desk.

Across the room, his back to me, a man wearing a familiar green plaid flannel shirt slumps in a wheelchair. "Chris?" His spine straightens and his head turns, revealing a sad, pale face, a why-am-I-here-what-is-happening-to-me expression he rarely lets me

see. I can't imagine what he sees in my face. I pull an oversized chair up close and take his hand. "Do you need something, want something to drink?" He nods and I look for someone to ask for ginger ale. A woman appears, I explain, she disappears and reappears with a can of soda. Chris takes a couple of sips and pushes it away. We sit, holding on amidst a sea of empty chairs in a generic space. I don't ask, wouldn't you like to go home?

Soon an aide comes to collect him, and I am left to find the Tower elevators to the sixth floor Pod B, among Pods A to D. I press the button to activate the double doors to a crowded area where eight private rooms encircle a nurses' station. Everyone glances at the new face. Someone explains the rules—jacket and bags in this cupboard, purify your hands here, take a mask from this box, gloves in your size here—and points to room 29. I apply mask and gloves as directed and enter the outer set of doors to a small area with a sink and storage space for medical supplies, take four steps and push through another set of doors to an inner sanctum. The two sets of sturdy doors take me from the bustle of doctors and nurses—who will keep us safe, won't they?—to Chris's bedside. He looks up at me, alien female with anxious eyes, mouth and nose concealed behind a stiff white cup, hands bloodless in sticky, smooth latex. In limbo together.

I WATCH A TEAM of strangers string the IV pole with lines, hook up the feedbag, which looks like milk, and infuse two units of blood followed by two chemotherapies and many more medications by mouth. They bombard Chris with treatment. He feels better afterward, no nausea. To celebrate, for breakfast and lunch he downs an array of sweet things: fruits and juices, cream of wheat, tapioca, chocolate milk. Imagine the whirlpool of chemicals in his blood stream and vulnerable organs. I'm too nervous to eat.

We talk about how exciting Boston is right now. The Red Sox have just won the American League pennant, and all of New England is revved up for the World Series. Can the Sox possibly win after an eighty-six-year drought? Will the candidate we support, John

Kerry, win the presidency on November 2? Will we be victorious, a transplant giving Chris a longer life?

The doctor visits us in our cell. It's been four months since we've seen him. "Your white cells are still up, but they will come down. To be expected. Four days of chemotherapy will kill as many blasts as possible to make physical and immunological space for the donor stem cells to move in. The treatment destroys the immune system so that it won't reject the new cells."

I imagine a complete cleansing, emptying the body-chair. Please come inside, new life, be my guest. I welcome you, stranger.

We listen like stones. "After you receive the transplant, it will take two to four weeks to know whether the graft has taken, in other words, to see if any donor cells are in your system. You will go home and return twice a week for us to check it out." We nod respectfully, storing this information without question, grateful to have the attention of experts.

Chris sleeps all afternoon, feverish, his face flushed. I sit next to his bed in mask and gloves and read the *Times*. Through the one large window behind me, the afternoon sun reflecting off a skyscraper glares like a spotlight. No music plays in our inner sanctum. The only sounds are those of the equipment surrounding his bed, a wall of monitors delivering persistent, maddening, high-pitched beeps; and muffled sounds beyond double doors of nurses and technicians talking, laughing, at home in this institution. Every fifteen minutes or so the outer door clicks open and a masked guard enters to check Chris's vitals or to put a tiny plastic measure of pills on the tray table. When he wakes up, his speech is slurring. This man who loves to eat gags at the sight and smell of food. This man who loves our reading-aloud sessions nods off a few sentences into whatever I begin, a news article or Gothic novel.

On Halloween we're both in costume, I in requisite white mask and gloves, Chris in a hard-plastic, bucket-like oxygen tray that juts out from the lower half of his face. He had another rough night of fever, vomiting, and diarrhea, but feels okay through the day until it hits him again around six: incontinence, chills, some mental confusion. He needs his bed changed twice. Earlier, though, we

read emails out loud. I cried over the loving kindness so many expressed. Chris took a shower. Everything comes in waves.

When I get ready to leave, around 7:30, he takes my hand, his eyes lowered. "When I leave you, when I'm gone, you should enjoy things, other people. Do what makes you happy." He looks up at me, trying to be convincing, giving me instructions as he begins another incarceration. All the metaphors that come to mind are punitive, threatening. We are criminals, and I can only witness the deepening chasm between us.

"No!" I shake my head, horrified. "I don't want to enjoy other people, I want you, I've always had you!" I am crying, again, and he looks stricken. Since I can't control myself, we say good night. Outside, I hurry through the chill air with downcast eyes, turning away from streetlights and pedestrians, trying to hide my naked face, tears I cannot stop.

■ ■ ■

Modeled on a stone boat or sled, this sculpture refers to the heavy and constant work with teams of oxen or horses that early settlers did to clear fields of stones to be used in construction. During the witchcraft phenomenon, a sled was used to inflict torture. In one case, the method of torture, derived from the European Inquisition, was to slowly pile more and more rocks upon the chest of the accused until he or she relented and admitted to being a witch. One victim, in this case a man, Gilles Corey, stayed completely mute throughout the excruciating process of crushing. After his death, excusing their culpability, the magistrate stated, "His life passed accidentally from him."

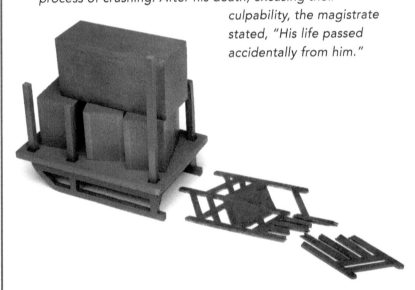

CRUSHER SLED CHAIR

November 2004

MY CELL PHONE rings as I'm crossing Beacon on Election Day. "The doctors want to talk with you about continuing. They say there is so little chance of a transplant working, why go on." I try to rush, but the T is a ten-minute wait and crowded. No fee, the fare box is full. After jogging the four blocks from the train, I sit on the edge of Chris's bed, my chest heaving. My heart rate slows gradually. The air in the room is heavy, somber.

Chris takes my hands in both of his, forces my eyes to meet his. "I feel my body is quitting, that maybe it's time for hospice at home." My head drops. "Please don't worry. Our love is entering a new form." I look up, panicking. What is he talking about?

"I love the form it's in now!" That's all I can say. I don't ask him what he means. I don't talk with him about it. I'm emotional, irrational; he is calm and measured, has it all figured out. The phone keeps ringing but he won't answer it. He doesn't want music on or to be read to. He disappears into sleep, so disappointed in me, I'm sure. I watch him breathe, and breathe with him, and remember it's Election Day. What do we elect? This journey is about to take another turn. Turning, turning.

The doctor comes in — to cover his ass, no doubt. "I didn't want

to go ahead with the transplant last week when you arrived."

I say, "I didn't get that message."

"I did," Chris says.

I stare at them, shocked at the miscommunication. Why then did they go ahead instead of sending us home? What haven't we been talking about? Has Chris been trying to tell me he's ready to stop treatment? I'm suddenly all alone, crushed under the weight of male voices.

Before making a final decision to abort the transplant, Chris and his doctor agree to consult the medical team in Connecticut. Why are they doing this?

Chris talks with the doctor he has trusted most these past six months, listening, nodding, then turns to me with their decision: "The cells have already been collected, so why not go ahead? If the transplant doesn't take, I will be on an oral chemo at home." I weep plenty, unable to think what to do. I must be resolute because Chris is. But if the doctors here at Dana-Farber want to send us home, why are they agreeing with the doctors in Connecticut to go ahead? It's all very confusing.

"At home, at home," they keep saying. When will we be there again, together?

Chris closes his eyes and I turn to my notebook, as usual, to figure out what I think. "I attend to you as I always have, your stepping-out-ahead, mother-certified guide on a forty-year tour, my marriage to an artist her ideal, my life hers in duty and in fear, hers in yearning, in submission. The necessary lost."

What surprising words, such thoughts spilling out from somewhere deep inside, but why? I don't know why my mother comes to mind now. Must I blame her for bringing me to this dreadful moment, as if my whole life has been of her and for her? I her living doll. Self-direction and self-confidence — the necessary lost? How revealing, how disturbing an image of the compliant young woman I seem to have been, the task of pleasing mother and grandmother having trumped my own nature.

The social worker invites me to her office, where I sit in the chair she indicates and cry, long, hard, wild, and loud. She watches until

I've exhausted myself, then talks about conversations our family could have toward the end. She fills the air with reason: "Josh can ask Chris about being a father, get his advice, and share memories." I look up at her, competent behind her desk in a windowless room, and nod to whatever she says, even though it sounds like bullshit to me and I want to scream with rage. I have no words for the torment I feel, for her failure to hear me and help me feel a little less alone.

Do WE — will we — regret how we voted, regret everything, voting for Kerry, voting to submit Chris's body to the ravages, but also to the hope of a transplant, voting to put him through more abuse and humiliation?

Like the colonial-era sled, pulled by oxen, essential for the hopeful labor of clearing homesteads from wilderness, hauling boulders and tree trunks, and building a new life in a new world, a necessary good could also be evil, torturing an individual into a false confession or crushing him or her to death. A tool for life or death, like a stem-cell transplant.

At 4:00 in the afternoon, a nurse enters with the stem cells in an IV bag. The social worker is here talking with Chris about the past, the two of them barely noticing the attempt to extend the present into a future. Watching the nurse hook up 480 milliliters of stem cells, equivalent to a can and a half of soda, I am riveted to the miracle seeping through the line. It looks murky, like V-8 juice. It feels anticlimactic after waiting all day, after waiting seven months.

The social worker, her short and solid self, her color-coordinated self, natters on to Chris about saying goodbye. "Why not have an art-latch party — like a Native American potlatch — before death, not after, where you invite everyone you know and let them choose one of your pieces. Maybe you can have an art-latch Thanksgiving and ask people to tell a story about you." But we aren't Native Americans, cries my inner voice. And why, oh why, does she go on about finality when we dare to imagine, holding our breath, a magnificent hello to possibility.

Turning to me, to include me, Chris says, "You can write me a poem called, 'Sometimes we forget to breathe.'" Has he been holding his breath all day, holding it for months, solid wall of breath, steel spine rigid against assault, never feeling the relief of a long, cleansing exhale? How impossible to breathe when heart spasms, chills, nausea, and lung fluids dam the blood flow to the diseased marrow.

A nurse asks, "Shouldn't Chris go to the ICU? He needs so much care." I am instantly offended, but our doctor doesn't respond. The social worker comes in to talk with Chris again, so I push my chair several feet back by the window, Bernie Siegel's book in my lap. I angle my face toward *Peace, Love and Healing*, and listen.

"How did you first become interested in rocks?"

"Playing in the Saddle River as a boy. The river flowed behind our house in New Jersey. Rocks are all unique. [I notice the lag between thought and speech.] A huge range of sizes. They move but very slowly. Light changes so fast. Painting is a summary of many instances — more real than a photograph. Rock is a huge metaphor."

She changes the subject. "Where do you want to go, to be at the end?"

"I felt guilty when my father died alone at Dempsey Hospital," he replies softly, his eyes lowered, ending the conversation. She has no more questions.

Chris's words for the rest of the day focus on bodily functions. "I need water . . . I've soiled . . . I need to sit on the commode." He sleeps most of the time. We won't know anything about the engraftment for at least ten more days. We will wait and wait. I tell myself to come in early tomorrow, to listen to him and talk. I want to ask how he feels inside, what leukemia feels like, as normal blood flows and organ functions, thrown terribly off course, struggle to right themselves, the body-colony in a desperate internal war.

When the social worker was talking with him earlier, and I was listening, Chris blurted out something I'd never heard him say before, about how self-critical I am, how nothing I do is ever good enough. I was surprised, but she didn't pick up on it. And so I want

to ask him about that. I wonder if my self-defeating habit of mind has always disturbed him. And if it did, why I didn't know. Or if I did know, and because he never pressured me about it, elected to sidestep whatever it was we might have discussed, a tactic I perfected.

Just as now I can't discuss the option of going home and waiting for death. What that might look like. How he might be made comfortable, how we might accept the inevitable together. That would constitute a rational discussion that I'm incapable of having. Denial is stronger than courage.

CHRIS IS FAR AWAY, lying flat on his back, eyes closed, vital signs monitored by beeping, blinking technology. He doesn't know I'm here. The social worker interrupts our silence to talk about DNR orders again, to be sure we are clear. Chris is very clear: No CPR, no respirator. I should be clear about his care. Just comfort? Or continue treating lung and possible heart problems. I answer quickly without discussing the pros and cons. "Yes, keep treating until we know for sure the transplant hasn't worked. It's been only one week." They all want to quit, but I don't. They must be frustrated with me, but no one questions my decision.

I sit next to the bed and turn the pages of *The New York Times.* A headline, "Life-or-Death Question: How Supernovas Happen," catches my attention: " . . . one a second or so, somewhere in the universe, a star blows itself to smithereens, blossoming momentarily to a brilliance greater than a billion suns." Wow, star suicide.

I think about how death happens, the difference between a bloodless, gradual fading away in white sheets versus exploding blood and tissue from a sudden accident, a bullet or bomb. Or a humiliating public hanging with everyone watching. Whether death is calm or violent reminds me of Bernie Siegel's comment that "we die as we live."

How has Chris lived? With gentleness — his a kind, sweet nature, and most importantly, with a philosophical mind that embraced

conceptualism and postmodernism, devoured Wittgenstein. Award-winning art teacher and artist, he inspired countless students to wrestle with visual problems and devise solutions that were theirs alone, not derivative. No mimicry. They should surprise him.

Noticing he is very hot, I lay cold, wet towels on his head and legs, and re-wet them twice. Soak a cloth in ice water, wring it out some, and moisten his dry, chapped lips. He's awake, but groggy. Which word — obtunded, stuporous — describes his condition now? Where is he on the ladder of consciousness? Where am I? In a state of dread — what's the word for that? — as I witness the war raging in the mysterious recesses of his body, piling on boulders of nausea, vomiting, fever. Piling on fear. Leukemia smothering each cell like the rocks that crushed Gilles Corey's body, like the terror threatening to annihilate an entire Massachusetts Bay Colony, God's chosen "New World."

I have a panic dream about Chris dying and my not being there, his body thrashing, his wild eyes looking for me. I wake up at 2:30 crying, heart pounding, guilty for not comforting him twenty-four hours a day. I realize that if he were my child, I would be sleeping by his side, holding him all through the nights, playing my proper role, exposing a vulnerability to love.

When I call the nurse's station, I'm told he had a calm night and is still sleeping. Relieved, I arrive at the hospital as sleet starts to fall. The morning routine proceeds as it does each day, and soon he goes under again. I study his sweet face. Whiskers are sprouting on his upper lip and a few on his chin. When he wakes up, he says, "I miss you."

I take his hand and lay my head on his shoulder, murmuring behind my mask, "Oh, I miss you too, my darling. I love you so much." I don't say: I have always thought of you as a unique other on a pedestal above and apart from me. He closes his eyes and slips away again.

I pick up my book bag and push my chair back toward natural light. I open *Peace, Love and Healing* to the section late in the book where Siegel begins a discussion of what happens as people

approach death. He quotes from Elie Wiesel's *Souls on Fire*: "When we die and we go to heaven, and we meet our Maker, our Maker is not going to say to us, why didn't you become a messiah? Why didn't you discover the cure for such and such? The only thing we're going to be asked at that precious moment is why didn't you become you?"

It's a good question to ask well before any precious, heavenly moment, if there is such a thing. "…we die and we go to heaven," Wiesel writes. Do we? Words are problematic, as if heaven and hell were actual locations somewhere out in the cosmos rather than conditions of the spirit here and now. Important questions should be asked now. Why didn't I become myself? Perhaps I have, and this shy, introverted woman is it. Yet, I know I've always wanted to be someone else, any of the accomplished women I admired. But, like many women, I seem to have both inherited and reinforced a habit of mind that made sure I would feel inferior.

Chris doesn't stir, so I continue reading Siegel against the sound track of beeping monitors: "What an honor it can be to share a person's last moments. And when we also realize that people have an incredible ability to die at the moment that is right for them, then we too will be able to see that dying can be the final healing."

It may be possible that Chris is able to accept his fate, feel peaceful, and even orchestrate the finale. I look at him. He breathes evenly with the help of extra oxygen. I sense he is reflecting on his life, and I wish I could talk with him about it without collapsing into a pathetic, weeping mess. I say I wish I could talk, but if I spoke the truth, I'd have to admit to my dark energy: our marriage, the potential for joy, constrained by a negative habit of mind. I chose to doubt rather than to believe we loved each other; why, why? Just because it wasn't — I wasn't — perfect?

IN MASKS AND GLOVES, Josh, Toby, and I sit in a semicircle around Chris's bed, careful not to disturb his sleep. Josh works on the *Times* Sunday crossword. Toby sketches. My hands are still, fingers entwined in my lap. When Chris wakes up, he asks Josh about his

constitutional law class; he asks Toby about his capstone project for a master's degree. They talk about what their father wants them to. "What we talk about when we talk about love," the title of a Raymond Carver story having popped into my mind. So often when talking about other things, having ordinary conversations, we're paying close attention, attending to love, demonstrating our devotion indirectly.

Years ago, I followed Carver's stories and the controversies surrounding their publication after his editor, Gordon Lish, reworked many of them. I remember agreeing with the poet Tess Gallagher that Carver had published the versions he preferred. Revision. When do you stop seeing again, wondering if there isn't another way, another choice of words to take you closer to a truth? Working on this story of a marriage is to look for some truth about a particular couple together for forty years, to find something true about the wife. Yet, mutable truths wriggle out of line when I reread what I've written. Not falsehoods, really, more a matter of emphasis, yes, and accuracy. Truth lies somewhere outside of, often beyond, words that the narrator tries to snag and anchor. I keep clearing debris and stacking reams of paper, building a tower for, and about, one woman and one man.

This journey is primarily Chris's. He said that when he meditates, or thinks, lying in bed day after day, he visualizes his art projects. Art first, it has always been so. While I sometimes resented it, I also understood the dedication it takes, as well as the time and plain hard work, and often the deep satisfaction, to disappear into a world an artist creates, to compose, shape ideas and emotions that emerge on paper or canvas. To control those outcomes may be easier, may even be, possibly, more satisfying than managing family life.

Sitting by Chris, witnessing all the hours of his sleeping — dare I say healing — I read that for ten thousand years the Inuit people had no word for robin. Now there are robins all over their villages. Better find words for things.

I watch the ABC evening news alone, wrapped in a hospital blanket against the cool draft from the window, waiting, waiting,

waiting for the doctor to appear at our door. He finally calls. "I will do a test tomorrow morning to see if donor cells are showing up. We've accomplished two big goals: to get the transplant and to get in shape to go nearer home."

"Yes," I say.

"Yes, blasts could grow fast, but they might not. Hope I can see him next week. Tuesday? Wednesday? If he can travel."

Right. I wonder what planet this doctor is on.

RELEASED FROM THREE WEEKS of captivity, where Chris's cells have been invaded by alien cells, whether for good or evil we won't know for weeks, we will take separate journeys to Connecticut, Chris in an ambulance back to Dempsey Hospital. I delay packing my car, preferring to linger with him, and we listen to soothing Brahms while we wait for discharge. The heart monitor has been moved out, his medications are in pill form, and most encouraging, he seems to have a little more energy. He needs to get dressed, so I get his things out of the closet. His pants fall to his ankles, but we have suspenders. At the last minute, I tuck Josh and Allison's wedding photograph and the scan of her womb in my tote bag. I forget Chris's robe on the hook behind the bathroom door.

Since nurses at Dempsey will help him get settled again on the sixth floor, I drive straight home, not wanting to go back there just yet. Walking into our house, I take deep, cleansing breaths in the cool rooms devoid of husband and sons. Every familiar object once belonged to family: the oak kitchen table, the spool bed I sleep in. The weight as well as the lift of inheritance. I nudge Gram's rocking chair as I walk by, trail my fingers in the dust on Grandmother Valley's piano and the silent Horton grandfather clock, no one here to reset the pendulum.

In the colonies livestock meant survival. An empty
chopping block — no chickens to behead or no pig or
lamb to slaughter for meat that could be salted and
barreled for the winter — meant deprivation or starvation.
When an animal went lame or sick or suddenly died
mysteriously, witchcraft and Satan's scheming were
frequently blamed. Persons known to have associated
with specific animals or their owners when such incidents
occurred were as likely to be accused
of being witches as those whose
specters so frequently afflicted
the community. Accusers
would recall (or fabricate)
similar incidents from
the past and
blame them on
the accused.

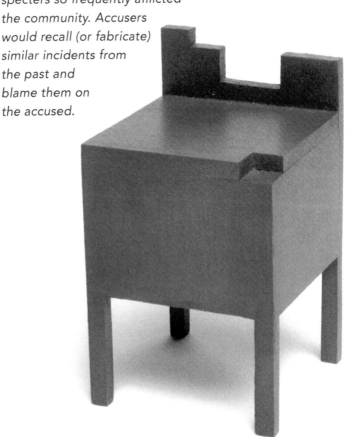

Chopping Block Chair

November 2004

I AGAIN SLIP INTO mask and gloves and join Chris in room 15. His sketchbook and pencils share table space with pills. I take his hand and tell him nothing is amiss at home after our three weeks away. "I went through the mail and paid the bills." I smile, "Nothing to worry about."

He nods, "Let's put my work up." As he indicates from his bed which piece to put where, charcoal figure drawings and watercolors of granite boulders gradually enliven the bare, white walls, and our spirits. At least two weeks before we will know whether the transplant has delivered a reprieve, a suspended sentence.

The next morning, I luxuriate in my own bed on Lovely Street, sun-soaked by two windows facing southeast, breathing yoga energy. Then I shed my cocoon and descend to the kitchen, put clean dishes away, towels in the dryer, and start the gentle wash cycle for sweaters. I decline my sister Lorraine's invitation for dinner — boeuf bourguignon and four berry pie — with her friends. As tempting as it is, I'd rather sit alone with pumpkin ravioli.

Lingering at home, I read another passage in Nuland's *How We Die*: "[O]f the many kinds of hope a doctor can help his patient find at the very end of life, the one that encompasses all

the rest is the belief that one final success may yet be achieved whose promise vanquishes the immediacy of suffering and sorrow." Two weeks ago in Boston, at that moment of terrible decision, whether to quit or to persist, believing in "one final success" gave us hope.

Clouds lower and darken. I can't stand the waiting. Twelve days before we will know something conclusive. Frustrated, I stomp along hospital corridors and accelerate to and from the hospital as fast as traffic allows; crashing, perhaps, from the twenty-three-night, pumped-up ordeal in Boston, the twice-daily commute on the T and long, long days in a cell at Brigham and Women's Hospital. No wonder I'm depressed now, having to face reality at home, waking up at one or two in the morning and padding downstairs in the dark to the kitchen window and not seeing — perhaps never again seeing — a soft light shining from the small hayloft window in Chris's studio.

Sᴀʟʟʏ ᴄᴀʟʟs from Florida to tell me she lit another candle of hope. Discussing hope, we discover we have the same first stanza of Emily Dickinson's "Hope is the thing with feathers" on our desks. I email her the next two stanzas.

> And sweetest in the gale is heard;
> And sore must be the storm
> That could abash the little bird
> That kept so many warm.
>
> I've heard it in the chillest land,
> And on the strangest sea;
> Yet, never, in extremity,
> It asked a crumb of me.

I wonder if we are in a storm sore enough to abash the little bird; but no, hope asks nothing of us. It's there for everyone, no matter what, a given of the human spirit. I remember the ovenbird

that visited us indoors in Maine, then marched off out of sight. We didn't need to hear a single note of its "TEA-cher TEA-cher" song to understand its determination to survive.

I read more in Nuland, who invokes Samuel Johnson: "Hope . . . is itself a species of happiness, and perhaps the chief happiness which this world affords." For today, hope will be our definition of happiness, and perhaps all along it has been my definition of happiness in marriage, hope spanning the abyss, as I've written, between us and between us and all the rest.

Toby, the hopeful son of few words, calls. "Lori is coming for Thanksgiving and making an apple pie. I'll be your sous chef for the turkey and stuffing." I see that we will carry on as usual. We will not have a Native-American-style "art-latch Thanksgiving." Chris isn't home and certainly isn't strong enough for a party.

At the hospital, he shambles to the unit doorway and back, leaning on the walker, clutching the IV pole, with one physical therapist behind him and another carrying the oxygen tank. I push a chair with two thick pillows in case he needs to sit down. Our thankful-on-Thanksgiving Day parade. He plunks into the chair and vomits his pills.

Words for the heart: Amiodarone, Diltiazem CR, Lisinopril, Toprol. IV words: Acyclovir, Lasix, Caspofungin, Pantropazole. Other words: Metronidazole, Guaifenesin, Ursodiol.

Can you pronounce the names of these drugs? Do you know how powerful, and how toxic, they are? Do we dare hope that they interact positively in Chris's body?

I STUDY THE CALENDAR and count the days since the transplant. Today is only Day 19. The first sign of graft will be on Day 30. Then, once we know that some donor cells are surviving, the battle between those cells and Chris's own will wage for many more days. I count them: 30, 60, 90, 100. Not until February 12, one hundred

days from transplant, will signs of chronic GvHD show up, reason to hope.

Chris is alert and attentive, and we watch the news. During a commercial, I cradle both of his feet in my latex-gloved hands. We lock eyes and say I love you. Behind my mask I remind him, "You've been in hell and are coming back. You are strong and brave." He nods, accepts my words. I leave the hospital to keep appointments for hair and car repairs. At home later, I watch *Judging Amy* and drink wine. I am happy.

THANKSGIVING MORNING Chris's eyes exclaim: you're late! I say what you're supposed to say: "Happy Thanksgiving!"

"Is everyone jolly?"

"Not without you!" The aide giving him a "bath" listens to our fakey exchange as he ties a clean, blue johnny behind Chris's back. Thin and weak, he nods off quickly after the aide leaves the room. When he comes to, I help him with the four cups of pills the nurse has arranged on the bedside table.

This is the first Thanksgiving in many years that I haven't been in crazy mode: polishing silver, critiquing the beauty of apple and pumpkin pies baked yesterday, worrying about the gravy, forgetting the cranberry sauce. No, this year I'm on vacation at the Dempsey Resort and Spa, sitting quietly and writing in the La-Z-Boy while Chris sleeps with an oxygen clip in his nose, IVs dripping nutrients and a diuretic, which will make him sit up suddenly and grab for the urinal. I notice his blood counts are low. I'm upset he didn't get any transfusions yesterday or overnight. Why not? Because it's a holiday, I think. No one is paying attention.

Soon an aide pushes through the door with a plate of food that bears some semblance to a traditional mound of gray, solidified gravy over gluey, instant mashed potatoes on top of a cold slab of turkey and tablespoon of stuffing, taunting this man who hasn't had solid food in how long? He pushes it aside.

With six days to go until news of the graft, I lay my head against

his shoulder and count the seconds on the large institutional clock, 1-2-3-4-5, 1-2-3-4-5, annoyed when the second hand doesn't strike the number exactly, when it's off a little. I remember counting the seconds when he stopped snoring, tiny deaths through years of nights. If he didn't jumpstart after twenty, I poked him, my scientific method of treating sleep apnea.

I make a To Do list: Send a thank-you card to the Art School for the beautiful Thanksgiving bouquet of rusts and yellows, which could not be brought to the hospital. I think about their thoughtfulness. Over the years, of all the people we meet, people we work with, people who live nearby, some remain planted in the rich soil of the heart and take root and grow whether or not we pay much attention. Years, even decades go by, and a tiny green shoot pokes through concrete. Enduring surprise.

If donor cells win the battle in Chris's marrow, he will have a new blood type. He will have childhood immunizations again. He will be a different person, in the most fundamental sense, at the cellular level.

I forget my cell phone. I'm freezing in this room, shaky with anticipation.

EMAIL FROM DANA-FARBER: "Chimerism coming with Friday's blood test. I'm hopeful there will be some engraftment, but that does not predict the long-term success of the transplant." Chimerism? I look it up: "In Greek mythology, the Chimera was a fire-breathing monster with a lion's head, a goat's body, [Chris's sign is Capricorn] and a serpent's tail; any similar fabulous monster; an impossible or foolish fancy."

These last words strike me hard. How impossibly foolish are we to imagine that at Chris's age younger cells might prolong his life? If they did, would I have a new and different husband? And while the doctor says he hopes — that word again — to see signs of two genetically distinct tissues in Chris's blood, look how he warns us not to count on it.

The Chimera reminds me of the *Graugh of Cranbaughstrau*

in 1965, Chris's large ink and watercolor drawing of a Dali-esque, whimsical, erotic monster giving birth to a baby Graugh (Chris in love). Could such wonderful, serious re-vision be a literal possibility? Can we really have a do-over? Get it right this time? If I have a new husband, will my new husband have a new wife? Will a strong, confident woman clear the wilderness and plant new fields?

CHRIS'S EYES ARE WILD as December roars in, treetops thrashing. I hurry to him and take his hand. "What's wrong?"

"I can hear only in my right ear; the music I want to listen to sounds all scrambled!" I turn to the nurse, who reads my alarm.

"They are checking to see if a medication other than chemo could have caused this."

How sick he must be of his sick body, I think, teary in the vinyl witness chair as two aides bathe him, turn him on one side then the other to wash his back, their movements efficient yet gentle, unhurried. Maybe the Verdi on WFCR is making me cry or maybe it's because I am thinking of Bill Hamilton's calming voice. He's Chris's childhood friend coming to visit us from his home in Venezuela. I told him he was making a Herculean effort. "I'm coming for myself, too, and for you. Big hug."

Bill and I linger over coffee discussing Artemisinin, the ancient Chinese herbal treatment for malaria now getting some attention as an alternative cancer drug. When he leaves to visit Chris, I put two sets of sheets in the washer and, after he calls to say he's heading to the airport, drive to the hospital, hyper-aware of how alone I am. Tears soak my face, "Let the Sun Shine In" on WDRC is cranked high. We returned from Boston more than two weeks ago. There has been no improvement in Chris's condition. The sun is not shining.

Chris says he didn't sleep, first because his head and bones ached; then he says he didn't sleep after Bill's visit. He must have been thinking about their friendship all through the low lights and footfalls of a long hospital night, both men in their sixties, friends from Boy Scouts through high school, college, the Army, and

beyond. Chris the artist, Bill the writer. I remember amusing stories about drunken carousing and their fantasies that after college in 1958, the Korean War ending, they would become French-speaking spies in Europe, only Bill realizing that dream with his superior command of spoken French. Chris served his required two years at an Army outpost on the DMZ, where he interviewed poor Korean peasants who were rounded up and accused of suspicious activities. In that isolation on the other side of the world, he passed the time carving woodcut portraits of those peasants and, in the satisfaction it gave him, made up his mind to become an artist and art teacher.

The doctor comes in to examine him. "Your bones may be aching because of the graft versus host disease (GvHD), and the anti-rejection drug can raise blood pressure. High lymphocytes and monocytes might be good or bad, a sign of leukemia or of graft. Can only wait and see." They have no idea! A war rages within, but there are no informative clips on the evening news about that invisible world, no ministers or magistrates to interpret this experience. Wait and see. Wait and see.

I read in *The Times*: "Astronomers have concluded that a mysterious 'dark energy' is wrenching space apart, a discovery that has thrown physics and cosmology into an uproar." Isn't leukemia our mysterious dark energy, wrenching Chris's internal space apart. Cell suicide. I think about the crisis so long ago in Salem that Chris is writing about, the Puritan belief that the invisible world was a dark force wrenching their visible world apart. The God they believed in, distressed that his chosen people were no longer humble enough, too independent, had sent the devil and his minions, Indians and witches, to threaten them with severe punishment, even with possible annihilation of their New World.

Chris is incontinent. An aide, a tall stick of a young man, cleans him up with soapy cloths he microwaves before gently wiping the soiled skin. Watching him, I think about Chris's quality of life. It's the worst it's been. Even if the new cells don't engraft, he has to endure the dark energy of Flagyl, Acyclovir, Actigall, Lisinopril, Lopressor.

The doctor comes in to respond to articles I gave him about the positive effects of Artemisinin on chronic leukemia cells. "You can't imagine how many compounds affect cancer in cells but not in people. And remember, Chris has acute leukemia, not chronic, which affects a different part of the cell." He looks me in the eye to be sure I get this message: "Artemisinin could attack the graft, so don't use it while we are waiting for news of the success of the transplant." I nod to let him know I understand. We won't do anything radical unless the transplant fails.

Whether a gallows was built or the convicted was strung up on the limbs of a large tree on a rocky ledge overlooking Salem and its estuary, this English and colonial method of execution was both horrific and spectacular. ✦ The hanging events of 1692 were hugely attended public affairs. Provincial leaders and masses of people came from as far as Boston to watch. While climbing the ladder to their fate, victims prayed, asked forgiveness, begged for God's mercy, pointed to the mistakes of the court, and restated their innocence. These supplications often affected their fellow citizens in the crowds who reacted with sympathy and regret for the inequity and miscarriage of justice. ✦ Afterwards, the bodies were piled in a common shallow grave nearby, from which some relatives were able to retrieve them and provide proper burial. Thus the gallows, which was hoped would end the invasion of evil and provide a catharsis for the community, was the ultimate tragedy of the time: a consequence of human error and foible.

Gallows Chair

December 2004

WITH THE OVERHEAD LIGHTS turned off, the hospital room is dim, a uniformly pale gray. Chris is lying on his back in bed, eyes closed, but I don't think he's asleep. I'm sitting close by, watching his chest rise and fall and writing in my journal by the clouded light from the picture window. We look toward the door when it slowly opens and the doctor and nurse practitioner enter with somber expressions. Avoiding eye contact with me, their eyes are riveted on him as they present the results of the bone marrow test. The PBSCT (peripheral blood stem cell transplant) has failed. Chris's marrow is full of blasts, dense with leukemia. I collapse in tears on his chest. He strokes my hair, murmuring, "I'm sorry, I'm sorry, I'm sorry."

As if he has failed me, as if he needs to apologize for failing me. How impossibly hard he has tried not to make me suffer. Not to make our sons suffer. My suffering, their suffering, not his, on his mind all these months. Not disappointing me and Josh and Toby is what's driven him to endure this terrible journey to the end of his life.

The doctor says, "There are no more options except hospice care in the hospital or at home. With palliative care you have a few more weeks, not more than six months."

I hide my crumpled face in Chris's chest, wishing I could climb in and disappear. I want no witnesses to this execution. Two nurses who know us well come in to try to comfort us. After a while, I somehow drive home, wrap myself in a blanket and curl up in Chris's chair. Defeat streams from my eyes throughout the night.

I wake up early, exhausted from crying and an upset stomach from eating too late, a chunk of buttery, baked winter squash more comforting than chocolate. When I arrive at the hospital, Chris is far away. He stirs while an aide bathes him in bed, then closes his eyes. When he comes around again, I continue in mask and gloves my habit of finding something to do to get us to one more lunch, one more dinner and bedtime, grabbing onto the small and necessary. Can't fall apart. He is looking at me, reading my swollen red eyes, touching me. I can remove his soiled johnny, retrieve a clean one and tie it across his back. I can walk out of the room and fill the pink plastic pitcher with fresh ice water. I can hand him his cup of pills.

"Do you want to watch TV or listen to music?" I ask.

"I'll look at *The Times*." I hand it to him with his glasses and think how he looks like a hawk, like his father who was ninety-three when he died. We are not talking about the transplant failure.

Always believing that silence between husband and wife is somehow wrong, later I find understanding and acceptance in Dr. Jimmie C. Holland's *The Human Side of Cancer: Living with Hope, Coping with Uncertainty.* "Often the conversation is mundane, but both patients and loved ones know and feel the poignancy and profound reality of the moment. Those unspoken emotions are exchanged as truthfully and powerfully as if their farewells had been verbally expressed. Sometimes, the survivor feels guilty for not having said more, without recognizing that the dialogue followed the same pattern that characterized all their previous interactions." Nothing magical or cathartic happens between us. We are ever the same husband and wife.

December 13

I'M SITTING as close to Chris's bed as possible, my gloved left hand resting against his smooth, hairless arm. On his back, arms and legs fully stretched out, he is far, far away. I hear someone on the floor cry out, a long "oh no" kind of wail. It's spellbinding. I stare at the door and listen. It stops after five or ten seconds.

I settle back and remember — why this memory arrives now I don't know — that Chris would never say anything negative about me. When I said something self-deprecating, he would insist, "I love you just the way you are." Liar, I accused in silence, yet if I didn't love myself, how could he love me? I baited but could never push him to criticize my cooking, my hair, my house cleaning, anything, although he sometimes, rarely, indicated a fashion preference.

At one Horton Christmas gathering in New Jersey, he watched me read the witty hand-made card, a tiny cartoon and hinting rhyme — never a generic To-From card in that family — and open his gift wrapped in wrinkled, recycled paper. It was a new dress. Not a dress I could wear to work, but a country-western style with a lacy, fitted, low-cut bodice, fitted waist and full, flouncy skirt. Perfect for Nashville. I was made to model it before his parents, our young sons, his brother's family, everyone amused. Blushing brightly, I mugged and twirled, exposed, feeling naked, "a charged image," and returned the dress as soon as I could. What was the point of that bizarre gift? Please show your body? Be proud, confident? But it had an opposite effect on me — abject embarrassment. I wanted no part of the domestic myth, the dream of a feminine wife who dresses to please a man, who is forever sexy, flaunting her curves. She was not the woman Chris Horton married.

I hear more crying out on the floor.

December 14

TOBY AND I ARE SITTING with Chris when all the big guns—two doctors, nurse practitioner, social worker—enter the room to meet with us. The nurse practitioner says, "At this point, I don't think you need to wear a mask. Let him see your face."

Ever since that first moment in Boston, every time I left and re-entered his room, half a dozen times a day, at least, I put a mask over my mouth and nose, sterilized my hands, and chose latex gloves from one of the boxes on the cart by the door, careful to touch only the gloves. Everyone who entered his room did the same. I became grateful to be hidden, breathing hard into the stiff, opaque curtain over my mouth and nose, only naked eyes communicating.

Liberated two months later, I take the mask off; guilty, put it on; take off the gloves, put them on. It doesn't occur to me that I could now kiss him. It doesn't matter that I could spread germs from the outside world in this supposedly sterile space. What will Chris understand by this change? That I've given up? It doesn't occur to me it's what he might want. Has he been waiting all this time for me to recognize the truth and accept it, as he has? I won't. Not yet.

The doctor says, "If Chris has no more support for platelets and blood, he will last a week or two." The social worker talks about hospice care at home, which means stopping all transfusions and antibiotics, antifungal and anti-nausea medications. He would get meds only for pain, as needed.

After the others leave, the doctor says, "If you want to try Artemisinin, go ahead. But I have a problem with home hospice because they do not administer blood products. If Chris doesn't get platelets, he will bleed, and I don't want you to go through that." Relieved, I could have hugged him. I see that he was managing Chris's death—and managing me—believing the hospital could keep Chris more comfortable and me less anxious during the inevitable end game.

While Chris sleeps, someone—Miss Manners, it must be—steps

up to write this email: "Dear family and friends, Chris and I are thinking our warmest thoughts about each one of you, thankful beyond words for your concern, your generous offers of help, your staying power through these difficult months. . . . Although the stem-cell transplantation did not work and leukemia is again threatening Chris's life, we are praying an alternative therapy will have a positive effect. Chris certainly wants to continue beating Tim and Josh at Scrabble. 'Hope is the thing with feathers / that perches in the soul.'" Hope, hope.

The hope is that Artemisinin stimulates free radicals, which form in the body normally, to attack cancer cells. The worry is that Artemisinin might attack normal cells, much as standard chemotherapy does.

■ ■ ■

And he [Jacob] dreamed, and behold a ladder set up on the earth, and the top of it reached to heaven: and behold the angels of God ascending and descending on it. Genesis: 28:12

Belief in God and in an eternal afterlife in heaven was almost universal among colonial Americans. In the harsh conditions and constant threats of frontier existence, the notion that a whole life of Christian sacrifice, religious devotion, and good works could be destroyed by the machinations of the devil must have been most horrific to contemplate. Almost worse than accusations and executions was excommunication from the church, breaking off the ladder to heaven.

HEAVEN CHAIR (JACOB'S LADDER)

December 20, 2004

C HRIS'S LEFT EYE is open. I stare into it as if I can see into his mind. "What are you thinking about?"

"Hymns."

"Which ones?"

"We Gather Together."

I sing it. "We gather together to ask the Lord's blessing. He chastens and hastens His will to make known."

Chris doesn't seem particularly thrilled.

I FIND A PIECE he wrote long ago about another familiar hymn from his Lutheran childhood. "Rock of Ages, cleft for me, let me hide myself in thee."

"What," he wrote, "was this rock, breaking apart (I think I had to look up cleft), letting me climb in and then somehow concealing me. Letting me hide. But why would Jesus want to be complicit in my transgressions rather than making me stand out in the open court of the world? . . . Of course I knew somehow that the rock was a metaphor, assigning to Jesus all the many properties of rock . . . and I guess an occasional trip back to the complete safety of

a stone womb might prepare the spirit to struggle back into the awful world."

He "guesses" that believing in Jesus helps one cope with the "awful world."

For decades, perhaps like his father who retreated upstairs and closed the door to his den every evening to read and pray, Chris returned to the comfort of a "stone womb" every August in Maine, standing for hours and days painting at a forbidding shoreline, focusing deep psychic energy on the tiniest chinks and angles of the surface of stone. Alone with his "rock of ages," he left the rest of us, his wife and sons, his parents and cousins, to our own devices. Perhaps those meditative summer weeks sustained him in his studio the rest of the year as he confronted "the awful world" of masculine identity and power in large, startling paintings.

December 23

ON A WARM AND RAINY morning that will ruin a white Christmas, Chris doesn't know I'm here. The nurse says he felt sick all night. "Still," she adds, "the nurses all say how well he looks. His body will tell us when it's over. And it's not over yet. We'll know."

An exhausted, "Okay, fine," is all I manage in the way of communication.

An afternoon visit from three wise and loving artist friends stimulates more smiles and talk than Chris has mustered in a long time. I leave them and sit in the family lounge only to feel assaulted by piped-in Christmas carols I've sung all my life — "Oh, come all ye faithful," "Joy to the World", etcetera — now impossible to sing.

Because family members who always come for Christmas are coming this year, I shop for food, cook, clean house, and welcome them to our home from Alaska, Maryland, New Jersey, and New York. I find a Christmas card, a delicately drawn scene

of snowy woods, a path meandering into the background, a single red bird flying over trees into the distance. The message reads, "May your path be a path of peace. May your heart dwell in a world of love." I send this card, I shop for gifts. I decorate, minimally, but I drag boxes down from the attic and buy the usual seven-foot-tall tree. I spend time in these activities: holiday symbols, decorations, colors, meals, gifts, songs, cards, and wishes far removed from the reality of imminent death. I've clicked into a performance, a familiar one in which the unconscious runs the show.

During these rituals, I become more distant, more distraught, as if I had died and in my place marched a stranger, perhaps a "Stepford wife" kind of woman, a fake. And Chris? What effect does the family's performance have on him? As the trapped, humiliated victim/audience, he endures the visits — alone, alienated, a gray-white, dying object in an anonymous white bed, a tragic figure in an epic fiction. The "I" I want to be — perhaps that's giving me too much credit — the "I" I wish I could be, disappears.

December 24

CHRIS ALWAYS WANTS ME with him when the techs clean him up and so I arrive at 8:00, as requested. After an hour I am dismissed, "You can go now." I buy fruit and drive home, forgetting candles. I feel frantic wrapping gifts — how did these gifts materialize? — yet show up on time to sit through the traditional roast beef dinner and gift exchange with my side of the family. It's a surreal scene around Lorraine's *House Beautiful*-ly decorated tree, each member of the family the center of attention, one by one, as he or she reads a card, opens a gift, and holds it up for everyone to admire. I manage to smother fury at the interminable ritual. No one notices. Or inquires about Chris, for that matter. We act as if everything were normal, another "as if" experience, and to all appearances it is.

I escape to be with Chris, who is alert, his voice proud. "I have had a fine afternoon. I sat in the chair for two hours and lifted three-pound weights." We smile and hug. I watch him eat vanilla ice cream and take two Artemisinin pills. I give him his gift from my brother, a red fleece throw monogrammed with CHH. Chris's middle initial is N for Noble.

"Who is CHH?" I ask.

He laughs, "Christopher Hulk Horton!"

December 25

I CRY ALL MORNING, starting in the car with that damn holiday music, and continue crying when one of the aides presents gifts to both of us: a bag of candies, cookies, apricot jam, a scratch card, and for me a gift certificate for a massage. I hug her, very touched by her generosity. Chris holds out his arms and she leans over his bed so he can pat her shoulder.

I listen to *The Messiah* while Chris's eyes are closed. When the diuretic jerks him awake, he wants me to read the Christmas story. Surprised, I scurry around to find a Bible in an adjoining room and locate the relevant passage in Luke. At least I know where to look. I sit in the straight metal chair, my knees touching the metal bed rail, take a deep breath, shoulders back, and read in a quavering voice: "And it came to pass in those days, that there went out a decree from Caesar Augustus, that all the world should be taxed." Another historical power grab.

Soon Chris nods that it's enough. I wonder, but don't ask, what the story means to him today. Ever since I've known him, except for the recent entry in his sketchbook, he has said he was agnostic. Have I had it all wrong? We think something is true, how someone feels, what someone believes, but what if it isn't? What if there has been a change of mind, and we no longer know that person at all. But perhaps it's something else. Never mind the philosophical journey of the intellectual adult,

the biblical stories of childhood are at the core of our being, first dibs on faith.

Chris has always been something of a stranger to me. And I to him? Or maybe I a stranger to me. Today, in many ways I don't recognize his wife of forty years. Who that woman was, wondering who this one is, called a widow, a word that still sounds strange on my lips. Alien. Whoever she is, I'm getting to know her, gradually, as I write.

December 26

WE ASSUME PARALLEL POSITIONS on the narrow bed. I have to lean on my right hip and crush myself against him full length, shoulder to feet, to keep from sliding backward onto the floor. We read the captions on the muted evening news as the rest of the Hortons settle into their holiday gathering at our house. Beds aren't made, tables aren't set. Only the mashed potatoes Toby made are ready, and the Christmas bread and cookies Lori baked. I bought fruit but forgot to make fruit cup, and it's too late now. Tim will serve the traditional bourbon old-fashioneds, their Christmas dinner and gift exchange to follow.

Chris says, "I hope this is not a great burden on Josh and Toby."

"What isn't?" Does he mean hosting the family at home?

"My life or death."

This is after I've said how wonderful our sons are, how lucky we are. He agrees, I'm sure, but his mind is on the ephemeral moonflower blossom of grief, weighted beauty. His gift to us.

His mind may be on a letter he wrote to Toby years ago: "At times what we say and how we act may be negative and miscomprehending and we know there are things we should change about ourselves and relationships. Distance and Quiet seem to have been my standard mode of relating—which has not helped any of us."

He knew. His self-awareness, its stunning accuracy, the truth of

this one sentence changes everything about how I perceive the man I've lived with for four decades.

I think about my "standard mode of relating." It seems to have been repression, which hasn't helped our family of four either, each of us alone, independent in an archipelago of four islands. Our sons were to excel in everything they did, Toby talented in art, Josh in athletics, both excellent students. Chris and I were at the same university every day for twenty-four years, though we rarely saw each other, and few even knew we were married. That we valued each other's work, each other's being, was an invisible connection we didn't need to display or debate, a connection no words could fully describe. Our lives parallel lines.

In one of the notes Chris wrote to me in courting mode long ago, he had copied out thirty dictionary definitions of LINE, and added his own about his feelings for me. These are just a few of them:

> Mon cher cher Sher,
> Line (lin) n. To place objects along the edge of: as line the walk with flowers.
> [forever to your walk I will with flowers line]
> A long fine cord used in fishing
> [I hope mine will hold if the blue-grey-green blonde beauty is caught]
> Effective contact between stations, as: "hold the line, please"
> [PLEASE. PLEASE. PLEASE-I love you]
> A very thin, threadlike mark; specifically made by a pencil, pen, chalk, etc.
> [all these lines I forever dedicate to you]

His exploration of line goes on and on, intense, playful. How nonplussed I was in 1965, so young and naïve. How comforted I am now.

He is wakeful in the evening. He says his bones have been hurting, but he doesn't want pain meds. He takes a fourth Artemisinin pill

and asks me to put two more in the drawer for the morning. The charade continues.

"Do you want me to read to you?"

"Yes, that old book." He means *The Island Shepherd*, a book about the hermit on Manana Island, which lies next to Monhegan Island off the coast of Maine. The book was a gift from our friend, the poet Elizabeth Gordon McKim. He listens intently to it all, perhaps feeling marooned offshore himself, a line now broken.

December 29

CHRIS IS SIXTY-EIGHT TODAY, a deeply ironic birthday, and there's nothing to do but celebrate his life, all the purposeful years of days leading to this one. He is on Dilaudid for pain, a continual drip, and still under when I arrive after having a bad night, awake since 3:00 A.M.. At 5:00, our neighbor's plow clanked and rattled as he pushed gravel and only two inches of snow. I hurried to the hospital to escape the jostling morning scene at home.

I tell Chris that his family will visit later and then leave for home. Thinking I should play host, I go out to buy paper plates, plastic forks, forget napkins. Feeling ridiculous, I nevertheless buy a small chocolate mousse cake and squeeze out "Happy Birthday, Chris" in green frosting. It's what you do on someone's birthday. Chris's side of the family, the visiting Witherells plus spouses, and Lorraine and Bill, eat a bite of cake and gather around Chris's bed, one by one taking his hand and leaning in as they say their goodbyes.

Josh and Allison show everyone their birthday card on which they have written the names they've chosen for their baby, our first grandchild: Lucas Christopher or Siera Sherryl. I say, "Why not Sylvia, my mother's name? I like it better than Sherryl."

Lorraine scolds me, "You should be honored!" She's right, of course.

December 30

CHRIS IS NAKED, everything soaking wet. He is holding the urinal and peeing a little. I change the pad under him and his johnny and bedding, a dark wet circle on the bottom sheet. Soon a nurse changes and bathes him again. He is very groggy. "Is there any ceremony today?"

"No, we celebrated your birthday yesterday." He sighs, closes his eyes, and disappears into a deep, drugged state. Deep leukemia. I sit next to him and think how wonderful it was last night to eat leftovers with Toby after everyone had left, the holidays finally over. Blessed peace. No concerns about disturbing others when I get up during the night, alone with my routine in the morning. With just Toby here it's okay, I can be myself. Even though he has grown up and left home, as children do, at some level we are connected, just as island and mainland are linked by the invisible earth at the sea floor far beneath the visible surface.

I wish Chris could come home, but he may need platelets. We will have a cleaner, neater hospital death, nothing messy. I'm feeling very sad about this. Not about these facts, but how lonely it feels. Institutional protocols for blood transfusions have ruled our lives these past nine months. In April it seemed right to surrender to doctors and hospitals, disease the dictator. We were, or perhaps only I was, incapable of refusing any and all treatments medical science had to offer. Like the Puritans in Salem three hundred years ago, we believed in the power of authority to define the real. Understandable, perhaps, but mistaken, as they were.

But now? What in hindsight would we elect? There is no time left to change our vote, to revise this narrative.

In the evening Chris can only occasionally speak and make himself understood. "Stay," he tips his head toward the recliner. I understand he wants me to sleep there, but, oh dear, I can't do it. I need my own bed, my own bathroom. With nurses' eyes checking on us all night, I would get no rest, no necessary renewal within

those old rooms that anchor me, transform me each night. My devotion to my husband has limits I'm ashamed to admit.

I sit close and hold his hand. He'll get Atavan at midnight, so I know he'll sleep. Home at 11, I eat cold pizza and three of Lori's chocolate chip cookies, find a crazy movie on TV with Jack Black, Amanda Peet, and who? Owen Wilson. I laugh hard, go to bed before it ends.

December 31

I'VE ALWAYS HATED New Year's Eve, anticipating in a black mood its expectations for an impossibly happy time. I sit immobile by the bed, Chris unaware of my presence, my left arm and leg touching the sheets. Reaching into the ubiquitous book bag, I pick up Dr. Holland's warm, practical guide for patients and families. This time I turn to the chapter called "How Do I Go On?" and immediately start to cry over the epigrams, particularly one from Edna St. Vincent Millay's "Lament":

Life must go on; I forget just why.

I can't read the rest of them today.

Toby walks in, sinks into the recliner, and he and Chris stare at each other. I move back by the window. Flat on his back, Chris is no longer speaking. Is he obtunded? Stuporous? Semi-comatose? What does a word matter. I've stopped caring about words. Toby picks up his father's sketchbook and resumes a drawing of Chris's face.

When he stirs, we snap to attention, read his one good eye and the micro-movements of his arms and legs. He seems to want to let his legs hang over the side of the bed. A doctor comes in and suggests stopping IVs except for pain. "He will get platelets only if he starts bleeding." I agree but Toby hesitates. She explains, "His inability to enunciate isn't necessarily narcotics, but probably central nervous system (CNS) leukemia."

Toby nods, "I see. Okay."

At 6:00 P.M. a nurse says, "Look at the fireworks!" We line up at the picture window and peer into the distance where tiny colored sparks kaleidoscope in an early New Year's Eve display for children in Bushnell Park. The explosions zoom, burst, and fizzle at the same level as the top of the Traveler's Tower. After a few minutes I go over to Chris. "We're watching the New Year's Eve fireworks."

He moves one leg as if to get out of bed. "See the fireworks."

"But you can't walk."

"Oh," he murmurs, sinking back onto the pillow. Then I feel terrible that I didn't get him to the window somehow—how?—but it's too late, the show is over. Toby says, "They were too far away for him to see anyway."

"See the fireworks." Explosions of sounds, colors and patterns, each different and surprising, are, fittingly, Chris's last words and the last time we hear his voice.

UNEASY AWAY FROM THE HOSPITAL, Toby and I hurry through Lorraine's delicious New Year's Eve lobster dinner and head back to be with Chris around 8, Toby driving my car slowly along the narrow, winding, wooded Old Farms Road. Suddenly, so suddenly I'm thrown back in my seat, an enormous snowy owl swoops across the hood of the car, its left wing tip grazing the windshield. We both gasp and I cry, "Oh, hurry, hurry, you know what this means!" Not yet, not yet, wait for us, so afraid the owl has come to wing Chris's soul to another world. Yet I didn't know I knew anything about Native American lore or, even more astonishing, believed in animal spirits, but there it was, pouring from my mouth.

We find him comatose but breathing and take our positions by his bed for the night. I hold his left hand in mine. With my right, I wipe his face and lips with a soft moist cloth. Now and then I pick up a book I had chosen carefully, Thich Nhat Hanh's *No Death, No Fear*, and choose a short passage to read aloud.

*When you are about to die, you may not be very aware
of your body. You may experience some numbness,
and yet you are caught in the idea that this body is you.
You are caught in the notion that the disintegration of
this body is your own disintegration. That is why you
are fearful. You are afraid you are becoming nothing.*

Chris isn't fearful, or has shown no fear these past weeks. I am
reading the Buddhist perspective for my sake, and Toby's, having
searched for an interpretation of a "heavenly" transformation that
makes sense to me, closer to physics than to Jacob's Ladder. My
earth-bound voice reverberates through the otherwise silent room,
becoming disembodied.

*The disintegration of his body cannot affect the dying
person's true nature. You have to explain to him that he
is life without limit. This body is just a manifestation, like
a cloud. When a cloud is no longer a cloud, it is not lost.
It has not become nothing; it has transformed; it has
become rain. Therefore we should not identify our self
with our body. This body is not me. I am not caught in
this body. I am life without limit.*

Will Chris see fireworks, I wonder. Is he seeing them right
now — has he been seeing them since earlier this evening? Or will
he see them at the moment of death, like an exploding star.

January 1, 2005

I FEEL STRONGLY Chris won't die today. He's such a fighter, he's
not ready. While pale and well under two hundred pounds, his
big-boned frame doesn't look too emaciated. I hold his hot hand
and caress his arm. I tell him how wonderful he's been, how much

I loved him even when I was angry or resentful. I tell him how much I admired and respected his work, and him, how I could always depend on him, his body my furnace, my cuddly "Erbert Bear." I am chattier than normal, more positive, almost breathless, releasing a torrent of words, filling the space between us with a previously unspoken forty years of love. Last chance. I'm sure he can hear me.

A nurse checks on us around 9:00. "Swab his mouth as much as you want to. He's still putting out urine so his kidneys are still functioning. His breathing is a little labored. If it gets more so, let me know immediately. We can give him morphine to slow it down." She leaves.

She had called before 6:00 this morning. "Your husband has spiked a fever and his vital signs are changing. I thought you'd want to know."

"Yes, I'll be right there." I'd made coffee and grabbed the argyle sweater I wear all the time and jumped into the car, grateful it was warm for January. It was dark and I was almost out of gas. I flipped on WFCR. They were talking about living in remote places — one example they described is Whittier, Alaska. They said some people can live alone, others cannot.

The nurse reported, "At 5:00 he had a sudden fever of over 103 and a sudden, steep drop in blood pressure. I gave him a Tylenol suppository and now he feels a little cooler, but still very warm."

This young nurse, on duty during a long holiday night, stayed and talked to me, told me that years ago her thirty-five-year-old brother was hit by a car and killed as he crossed a road. She didn't stop talking. When her parents married in the 1950s, she said, they walked across the country to California. They had seven children and traveled all over the world with them, a new place every year for her father to shoot travel films. Her parents are eighty-two and eighty-seven now, she said, and they walk four miles every morning, have done that for thirty years, no matter the weather.

"I have to do that," I said, though I didn't understand why she

told me that story. Perhaps she was reminding me that we can survive the death of someone we love. We can go on, as her parents did, though right now, like Millay, I can't think why.

CHRIS'S GOOD EYELID FLICKERS. Both of my hands enveloping his left hand, I murmur on and on. The city of Hartford floats in gray fog beyond the picture window. Josh calls from New York, "I'm on my way, will be there around noon." Toby arrives and takes his place in the straight chair on the other side of the bed, holds his father's other hand. We get as close as we can to him. Our eyes are riveted on his face. He doesn't move so we don't.

We follow each whisper of air that exits and enters his mouth. His breathing speeds up and becomes shallow, then imperceptible. I don't notice when he leaves though I'm staring at his face, have been for hours, to be with him, to keep him here.

At 11:20 on the first morning of a new year, Toby says, "Mom, he's gone." Glassy stillness shatters. My head turns toward that voice. Clear, gentle eyes hold mine. "Dad's no longer here."

I turn to Chris, who looks the same as he did a moment ago, here yet not here. I don't know where he is.

Toby says, "I'll leave you alone." Perhaps I nod. I don't move when he stands and passes behind me to the door. The handle clicks once, twice.

My husband and I are alone where there is no time. My eyes on his face, I let go of his hand, releasing everything I've been holding onto, forever, it seems. I smooth the skin cooling on his arm, on his forehead, like parchment, my fingers light as brushstrokes.

MY HUSBAND'S BODY TRAVELS in a hearse to a crematorium, where it is incinerated at 1400-2100 degrees Fahrenheit; all tissues and organs, all soft matter reduced to gases and released through an exhaust system into the eternal atmosphere over western Connecticut. The bones, which survive such temperatures, are crushed in a pulverizing machine to brown-gray dust. Like every

body undergoing cremation, Chris's body is transformed to air and to dust. That which remains.

A week or two later, the long, glistening black sedan from the funeral parlor pulls into the driveway. I have been looking for it. The driver in a black suit and solemn expression carries the "cremains" in a rectangular black plastic box onto the porch and hands it to me. Our silent exchange takes seconds. I'm sure I say thank you. I shut the door and clutch the six pounds of husband—four to six pounds the average weight of a pulverized adult male skeleton—to my heart. I don't sit down or climb into our bed. Toby, working outdoors, creeps by the window and glances in at me where I stand, rooted, rocking back and forth, pressing the weight of forty years to my chest. My body opens, consumes it, and I wail until I can no longer breathe.

ACKNOWLEDGMENTS

SPECIAL THANKS TO PETER MCLEAN for his artistry, inspiration, and generosity of spirit. I have borrowed many of his chair designs for the resonance they spark. I am thankful beyond measure to Anne Batterson, Lou Mandler, Chivas Sandage, Ann Sheybani, and Sally Terrell for thoughtful responses to countless drafts, for their unflagging support and understanding of process that propelled me through years of doubt. Thanks for encouraging words from Anne Campbell, Bill Leatherbee, Pam Lewis, Lorraine Longstreet, Elizabeth McKim, and Abbe Miller; editors Alexandria Marzano-Lesnevich and David Rosen; and my publisher, Christine Cote. And, of course, boundless love for the late Chris Horton, our sons Josh and Toby, and their families. Writing this book has been a journey toward healing for which I am deeply grateful.

Below is a list of works consulted for the Salem Witchcraft Chairs project:

Axtel, James. *The Invasion Within.* Oxford Press, 1985.

Bailyn, Bernard. *Voyages to the West.* Vintage Books, 1988.

Bourne, Russell. *Red King's Rebellions: Racial Politics in New England, 1675 - 1678.* New York: Athenaeum, 1990.

Demos, John. *Unredeemed Captive: A Family Story of Early America.* Vintage Books, 1995.

Fischer, David Hackett. *Champlain's Dream.* Simon & Schuster, 2008.

Jennings, William. *Invasion of the Americas: Indians, Colonialism, and the Cant of Conquest.* New York: Norton, 1975.

Lepore, Jill. *The Name of War: King Philip's War and the Origins of American Identity.* New York: Knopf, 1998.

Leach, Douglas Edward. *Flintlock and Tomahawk: New England in the King Philip's War.* New York: Norton, 1958, repr. 1966.

Lorant, Stephen. *The New World, the First Pictures of America.* New York: Duell, Sloan and Pearce, 1946.

Norton, Mary Beth. *In the Devil's Snare: The Salem Witchcraft Crisis of 1692.* New York: Vintage, 2003.

Pynchon, William, Carl Bridenbaugh, and Juliette Tomlinson. *Pynchon Papers II, Selections from the Account Books of John Pynchon, 1650 - 1697.* Colonial Society of Massachusetts; Distributed by the University Press of Virginia, 1982-1985.

Roach, Marilynn R. *Salem Witch Trials.* Vintage Books, 1988.

Rowlandson, Mary White. *The True Story of the Captivity of Mrs. Mary Rowlandson among the Indians and God's Faithfulness to Her In Her Time of Trial.* Tucson, Arizona: American Eagle Publications, 1988.

Schultz, Eric and Michael J. Tongias. *King Philip's War.* Countryman Press, 2000.

Slotkin, Richard. *Regeneration through Violence: Mythology of the American Frontier, 1600 - 1860.* Wesleyan University Press, 1973.

Wood, William. "New England Prospect, 1634"; ed. by P. Vaughan. *The Commonwealth Series,* Vol. III. Amherst, Massachusetts: University of Massachusetts Press, 1977.

About the Author

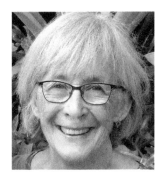

Sherry Horton is a retired English teacher. At the University of Hartford (Connecticut), where she was director of the Center for Reading and Writing, she taught in the writing program and co-authored a textbook challenging traditional approaches to composition entitled *Reading Our Histories, Understanding Our Cultures* (Allyn & Bacon 1999; 2003). A co-founder of the East Hill Writers' Workshop (www.easthillwriters.com), she is currently working on her mother's oral history of the 1920s and '30s in the remote Northeast Kingdom of Vermont. Mother of two sons and twice a grandmother, she spends as much time as she can outdoors. She lives in Unionville, Connecticut.

Witness chair : a memoir of
art, marriage, and loss

CPSIA information can be obtained
at www.ICGtesting.com
Printed in the USA
BVOW07s0109011016
463480BV00010BA/14/P

9 781941 830369